CARTOON ANIMAL FRIENDS

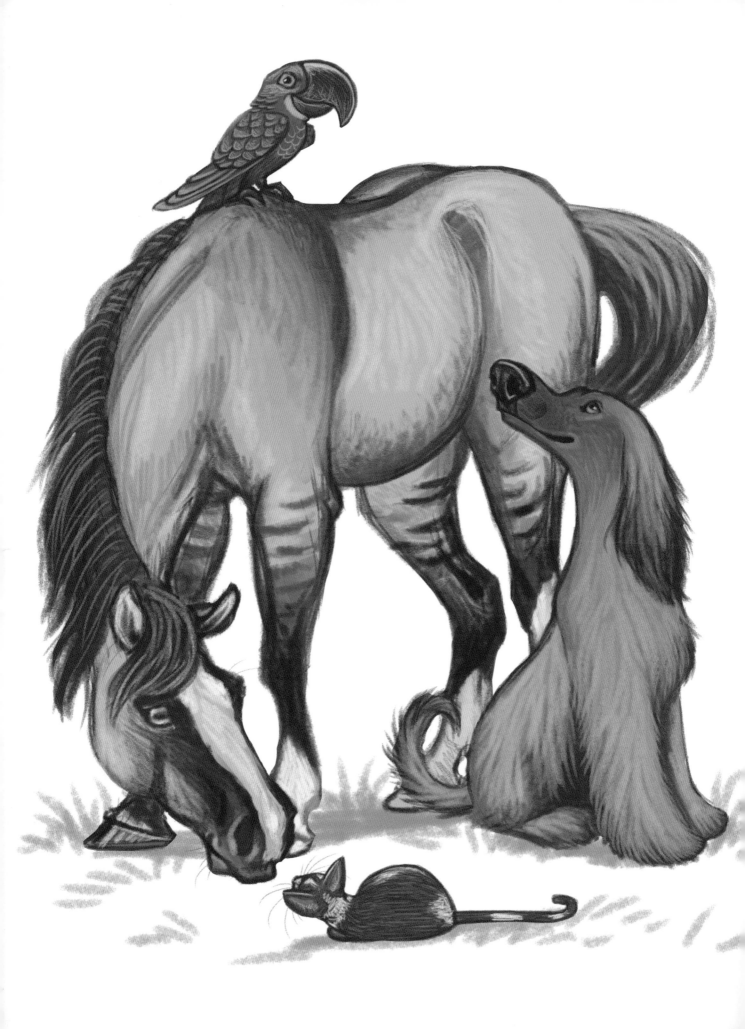

CARTOON ANIMAL FRIENDS

Char Reed

IMPACT
CINCINNATI, OHIO
www.impact-books.com

CONTENTS

INTRODUCTION

How much do we love our pets? We spend millions of dollars on them, buying everything from Halloween costumes to treats to fancy collars. We love them quite a lot! One of the many ways we show our love is through art. The many types of pet art span from ancient cave paintings from the dawn of time to masterful works by Renaissance painters to the early scribbles children make of their pets. Many styles abound, from the cartoony to the realistic. This book will show you how to blend these two styles in order to achieve something totally unique for your own cartoon animal friend!

HI! I'M **DENVER**, THOUGH YOU MAY BETTER KNOW ME AS THE "GUILTY DOG" FROM MY VIDEOS ONLINE!

CHAPTER 1

MATERIALS AND TECHNIQUES

People have always felt the need to create and have always found a way to do so. From berry juice on cave walls to advanced digital technology, if there is a way to be creative, people will find it.

When starting a new artwork, the most important thing isn't deciding what to draw with but just to start drawing. You will find your favorite medium—whether pencil, ink or color—in time, but the skills needed to create a successful piece stem from a good foundation and understanding of form and technique.

VISIT IMPACT-BOOKS.COM/CARTOON-ANIMAL-FRIENDS FOR EXTRA CONTENT.

TRADITIONAL TOOLS

Most people start their artistic careers as children with a piece of paper and a crayon. Nothing is stopping you from continuing with that tradition! However, you may want to upgrade to more sophisticated tools in order to get more details in your artwork.

Traditional tools are commonly separated into two main categories of "wet" and "dry" media. Dry media includes pencils, charcoal, chalk and pastels. The most common and readily available tool is the pencil. It's extremely versatile and erasable, allowing for mistakes. Colored pencils allow for color to be added. Charcoal can be messy, but it is fun to use with a blender, such as a tortillon or a kneaded eraser. Pastels are similar to charcoal, but they come in a variety of colors.

Wet media includes inks as well as acrylic, watercolor and oil paints. They require a brush or special pen to employ them. Paints can be used on paper, but most types of paper will buckle when wet media is applied. It's best to use specialty paper or canvases suited to wet mediums.

TRADITIONAL TECHNIQUES

There are many techniques to be had within the realm of traditional media, and many books have been written about each technique! Here is a sampling of the techniques you can use to make your art.

Blending With a Tortillon

A tortillon is a small paper stump that allows you to blend graphite and charcoal without using your fingers. Your fingers can be used, but they will leave oils on the artwork, which will degrade the piece over time. The tortillon can blend for you. You can easily create a tortillon by tightly rolling up a paper towel and then placing a piece of tape around it.

Stippling

Stippling is a technique where you place small dots next to each other, either closer together or farther apart to create the effect of shading. Some people place dots randomly, whereas others take a uniform approach and add dots in groups of two, three, four or more.

Crosshatching

Hatching is where you create parallel lines of varying thicknesses, spaced either close together or far apart. Crosshatching is when you place lines over hatched lines in another direction. This is a great way to add texture to a piece.

Inking With a Pen

Inking can be done many ways, but one of the most popular is with a pen. India ink is a dark pigmented ink, and by using a specialized pen, you can create a lot of the dry media techniques, as well as intricate line work.

Acrylic Blending

Acrylic painting has become increasingly popular because it is versatile and doesn't require the extra materials oil painting requires. You can add water to acrylic and create a watercolor-blending effect, or you can apply the paint thickly and blend colors together right on the canvas.

Watercolor Washes

Watercolor is a simple medium in that all you need is paint, a brush and water! One of the many different techniques in the medium is called a wash, where you apply layers of paint to the paper. You can work using the wet-on-wet method, which blends colors together while the paint is still wet, or you can do the wet-on-dry method, where you let each layer dry completely before adding more paint.

DIGITAL TOOLS

A newcomer to the art scene, digital media has been used since the 1980s but has really flourished at the turn of the twenty-first century. Computers have become faster, allowing real-time paint strokes and blending, much like what's done in traditional media. Some painting programs mimic traditional media, whereas others have a crisp, clean digital look about them.

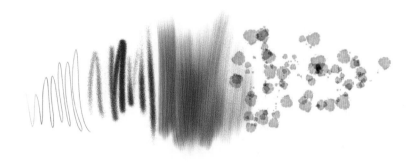

Many programs mimic the look of traditional media. In some cases, digital brushes look like pencil, ink or even watercolor! The benefit to painting digitally is ease of cleanup, a lack of fumes and lower cost over time. Initially, however, the cost of a computer and software is relatively high. If you already have a computer, you can find many programs that are free or not very expensive.

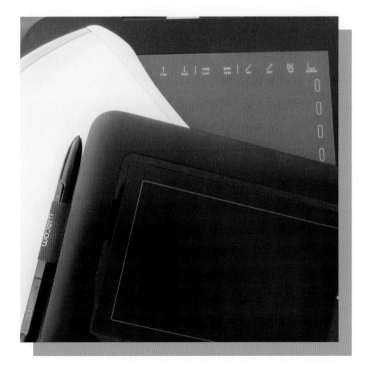

You can interface with the computer in different ways. The first way is to use a mouse. This can be cumbersome and tiring for your hand and arm after a while. A better solution is to get a graphics tablet. Several companies produce affordable models, and the tablets work with all kinds of computers. Tablets can range from a small, flat rectangle that you draw on off to the side while you look at the monitor to larger tablets that are monitors you actually draw on. All tablets come with a stylus, which is a modified pen that allows you to work in a more traditional manner.

DIGITAL TECHNIQUES

Digital techniques can be very similar to traditional techniques, though there is an added degree of complexity depending on how familiar you are with computers. If you have grown up with computers, you may find these techniques easier to accomplish than someone who is just getting into digital artwork and has less experience with computers.

Brushes

Depending on the program you choose, one of the first things you will notice is the awesome array of brushes at your disposal. Many brushes can be downloaded online for free. Some mimic traditional tools, some act like stamps and others apply textures to your painting. The best way to learn is to jump in and experiment!

Layers

One big difference between traditional and digital is the ease of layers in digital painting. Layers make it possible to create characters and backgrounds on individual layers. Additionally, different effects can be applied to specific layers, creating a new look to the layer below it. You have a lot of options when using layers. If you are worried, you can always stick to one layer!

Shortcuts

Each program has a unique look to it, offering different toolbars and keyboard shortcuts. It's important to dig into the Preferences of each program and see what all the different buttons do. Learning keyboard shortcuts can dramatically speed up your process and work flow.

Customizing Brushes

If you have a tablet, you can paint very similarly to drawing with a pencil. You can change the size of the brushes, allowing you to add more or less digital paint to your canvas. Additionally, you can adjust the opacity of the brushes. Doing so can allow colors to blend together. Once you're used to working digitally, you will have a lot of variety in your art and a lot of fun while creating it!

PAINTING FUR, FEATHERS AND SCALES

One of the most important aspects of drawing pets is their fur, feathers or scales. The outside of the animal is the most identifiable aspect of the creature. It's important for you to be able to observe the way the fur lays or to understand the shape of the feathers or scales so that you can make your drawing look as realistic as possible.

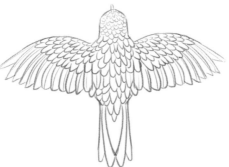

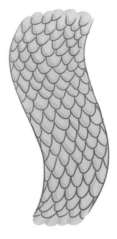

Fur

Fur can take many shapes, lengths and textures. In many cases, fur tends to clump in triangular patterns, especially when it's longer. You can create this look by sketching in triangles, then adding shade and light to give the fur texture.

Feathers

Feathers are made out of keratin, which is the same substance found in hair, nails and scales. Feathers look different depending on their function. In a lot of cases, the feathers covering a bird's body take a scalloped shape and the longer flight feathers form triangles. Create a feathered look by drawing semicircles that grow longer and pointier toward the wings and tail. You can add details like the center vein and individual feather tracts to create more realism in your artwork.

Scales

Scales are very similar to feathers in that they are both made out of keratin and they have a similar semicircle shape in a lot of cases. In order to create a scaly look, draw overlapping semicircles from the head down the length of the body.

Always look at your reference. Some animals have distinct fur or scales; others have rough, wrinkled or even pebbly skin. Some pets are completely hairless! Look at the animals in real life or from reference photos to see what kind of texture you should draw on your pet.

DOGS

Dogs are known as man's best friend, and most people who've owned a dog agree! They can be funny, creative creatures with wonderful and varied personalities. They also come in many different sizes and shapes, which means they're a great opportunity for making caricatures and interesting cartoons.

VISIT IMPACT-BOOKS.COM/CARTOON-ANIMAL-FRIENDS FOR EXTRA CONTENT.

TYPES OF DOGS

More than 150 different breeds of pure-bred dogs are recognized in the United States and countless more combinations of everything in between. Purebreds are deemed as such because they are bred for a specific purpose. The purpose largely determines what the dogs look like. Dogs bred for chasing swift prey are sleek and fast, while dogs bred for herding cattle stay low to the ground and are very agile.

Fur

Fur is one of the first indicators as to what purpose certain dogs are bred for. Most dogs with long, thick coats are bred in cold climates, and many are used as sled or cart dogs. Dogs with smoother coats are generally raised in warmer areas, and their coats serve a variety of purposes. Some coats are oily or have a specific texture that dries faster after being in the water!

Form

Form is the overall way a dog looks. Dogs take many forms, from short and squat to tall and thin, while others still are big and bulky. The different forms also demonstrate what purpose dogs are bred for. In the past, short-legged dogs were used to burrow underground to get at rodents or hares, whereas tall, thin dogs were bred to chase fast animals.

Wrinkles

Many dogs have wrinkles. Wrinkles and loose skin are bred in many cases for dogs who served as protectors. A wolf or lion might bite the dog and not actually reach any vital organs because all the wrinkles would get in the way! Some breeders simply like the wrinkled look and will breed dogs just for their appearance.

Size

Dogs come in all sizes, from tiny little dogs that can fit into a purse to big dogs that are taller than a human if they stand on their back legs. Size is bred for many reasons. Bigger dogs are bred to fight predators or protect livestock. Smaller dogs are typically bred to live in the house or to keep royalty company by sitting on their laps.

DOG ANATOMY

Dogs are quadrupeds, which means they walk on four legs. Their anatomy reflects this in the horizontal arrangement of their bodies, as opposed to humans who are very vertical and upright. The top of a dog's head, neck, back and tail are all in alignment when it walks, runs or lays down.

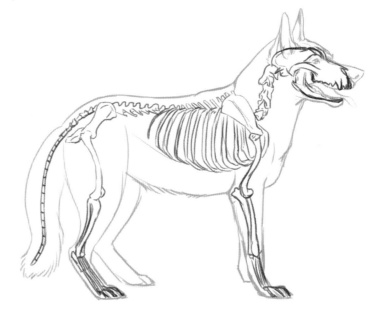

Head Shape

A dog's head is cone shaped, in general terms. Dogs with shorter snouts, like pugs, have more catlike facial features. The easiest way to quickly draw a dog's head is to start with a sphere, then add a muzzle to the front of the face.

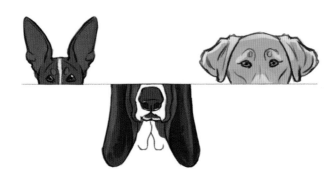

Ear Shape

Ears are typically triangular, though there are many different styles, some of which are created by humans. The ears of a lot of breeds, like huskies and rat terriers, are naturally large at the base, triangular and they stick straight up, similar to that of a wolf. Dogs have been bred to have different features, which can change the shape of the ears. Some breeds, such as basset hounds and bloodhounds, have low-slung ears that sit low on the skull and hang down below their mouths. Others, like labradors and mastiffs, have ears that sit somewhere in between, either partially standing up or folded over. Docked ears are those that humans have modified so that the shape of ears that naturally fold over appear upright again. Breeds with docked ears include Dobermans, schnauzers and pit bulls.

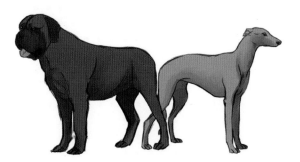

Body Shapes

Body types can take many different shapes. Many breeds have a deep rib cage with a narrower waist at the hips. Some larger breeds have a more rectangular frame filled with muscle. Also, if a dog is older, has excessive skin or is overweight, its body shape may be more rectangular.

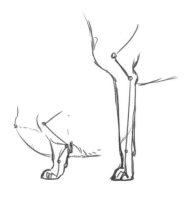

Legs

Legs on a dog are usually proportionate to its size, but not always. Most short-statured breeds were bred for a specific purpose; dachshunds were bred to burrow underground to get rabbits, and corgis were bred to herd livestock and be short enough that if a cow kicked at them, they wouldn't be struck. However, regardless of how long the legs are, they still have the same anatomy in the shoulders, elbows and wrist joints.

Feet

The feet of different dogs actually take unique forms. Great Danes are known for their giant feet as puppies. Some people guess how big a mixed breed might get based on how big the dog's feet are as a puppy. Some breeds, like malamutes, have a lot of hair in between their toes to protect from the snow and ice in their native environments. Other breeds, like the saluki, have hair covering their paw pads to protect from running on hot sand. Other dogs, like Newfoundlands, have webbed feet to help them swim better.

Tails

Tails are as varied as ears, and like ears, some tails have had some human interference in order to look the way they do. Tails are mainly used for balance while running and as a communication device. When excited, for a good or bad reason, dogs will wag their tails. Some dogs, such as Pointers, only have short hair growing over their tails. Others have long hair flowing from their tails, like Irish setters. Dog tails can also take a variety of shapes, from the super curly French bulldog to the gentle curve of a Shiba Inu. Humans can also dock a dog's tail. Originally this was done to signify the dog as a working breed so the animal would not have a tax applied to it.

ENHANCING THE FORM: CARICATURE

Cartooning and caricature is a unique art practiced by artists the world over. There is no right or wrong way to caricature. These tips help you choose which features about your dog to enhance and how to go about drawing those features.

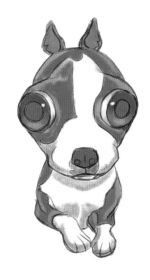

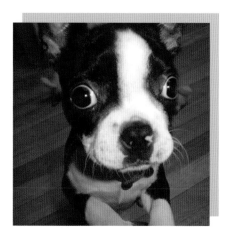

Exaggerate Features

Dixie is a Boston terrier. As you can see, this breed of dog has a lot of unique features. One thing that stands out is the eyes! In order to draw more attention to that, it helps to reduce other features to make room for the most prominent one. Start by making the mouth, ears and body smaller than they are in real life and then enlarge the eyes. This draws your attention straight to the focus of the caricature: Dixie's adorable eyes!

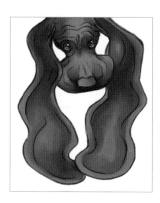

Noses

Noses are a popular feature to enlarge. Keep in mind, though, that not every dog has a big nose. Some breeds like Saint Bernards, Newfoundlands, mastiffs and shepherds do, so drawing attention to the nose is a great way to get a laugh!

Eyes

As we saw with Dixie's character, some dogs have very expressive eyes! Make other facial features smaller or less colorful in comparison in order to bring out the eye shape, color or size.

Ears

On some breeds, like the bloodhound, ears are all you notice! Be sure to play up these features by drawing them larger than they should be or in a crazy position. For dogs with long ears, drawing them wiggling all over the canvas is fun. Tall ears can take up most of the canvas, while the rest of the dog's head stays at the bottom of the piece.

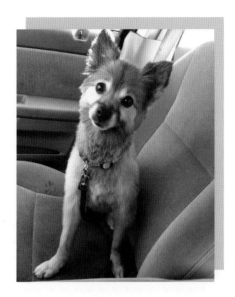

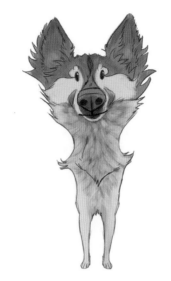

Adding Expression

Cheyenne's personality takes center stage in this photo. You can almost feel how alert she is. Perhaps she is looking at a treat? You can contort the shape of the body to fit her mood and emphasize her expression. All of her features are pointed straight at the camera, so be sure to reflect that in your portrait as well!

Body Language

Body language is so important in dogs! If you are paying close attention, nothing your dog does should come as a surprise to you. Ears can move in the direction of sounds, and dogs are sure to look at something, or someone, that catches their interest. Friendly body language consists of upright ears, wagging tail and open mouth. Unfriendly expressions include eyes with a lot of white showing, ears laid back, closed (or growling) mouths and tails tucked under or in between the back legs. Provide lots of energy in your depiction of body language by using broad strokes and flowing lines. Doing so will inject life into your drawing!

Markings

Markings are always varied and interesting in dogs. Some have spots, while others are a mix of many colors, like a brindle coloration. Most breeds have colors that are specific to the breed, so once you learn that, you can easily know what kind of dog someone has by its colors alone! When coloring your caricatures, try to stay away from black and white because they tend to be less interesting. Use light blue or purple for shading white coats, and use dark blue or purple in place of black for dark coats.

Fur Shapes

Fur can have a personality all its own! Some breeds, like poodles, are known for their unique coats. You can play with the shapes of the fur and really add to the caricature and personality of the dog. Tibetan mastiffs have huge, regal, lionlike manes while Afghan hounds have silky, luxurious coats that can be mistaken for a human's hair. Play with these fur shapes and textures to help give variety and interest to your cartoon.

BLUEBERRY

Part of the appeal of having a dog is the feeling of being close to something wild. Some breeds really harness this feeling. Many people love huskies due to the fact these high-energy dogs look very much like wolves!

Blueberry is a Siberian husky, a breed with boundless energy and lots of stamina. They are best suited for people with active lifestyles because these dogs are highly intelligent and get bored easily.

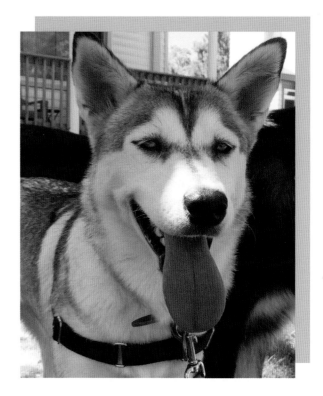

Blueberry has the blue eyes typical of the Siberian husky breed.

1 SKETCH THE BASE OF THE HEAD

Sketch a circle and draw a curved plus sign to indicate the direction of the face. The point at which the lines intersect will be where the nose starts. Be sure to center the circle near the middle of the page to leave room for the other features.

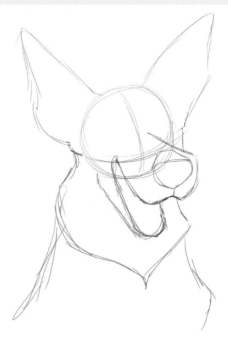

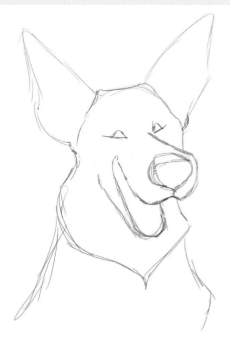

2 SKETCH THE EARS, FACE AND NECK

Draw two large triangles on either side of the circle. Making oversize ears will give the husky a great caricatured look! Add the line for the muzzle, making a rough sideways U shape that joins the bottom of the circle. Sketch an open mouth, continuing the sides of the mouth up toward the middle of the circle for a wide grin. Next, create a loose V shape for the fur around the neck. Add a line for the shoulder and back.

3 DRAW THE EYES

Sketch in two small pyramidlike shapes for the eyes. Huskies have small eyes compared to some other breeds. Making the eyes even smaller will enhance the look of the ears. Erase the guidelines on the face.

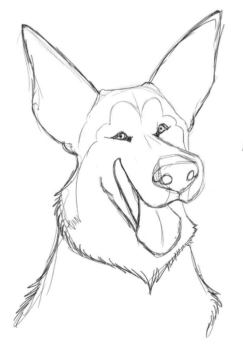

4 ADD DETAILS TO THE FACIAL FEATURES

From the open mouth, draw a U shape for the tongue. Once the tongue is in place, you can erase the guideline of the mouth. Add some texture to the fur, the pupils in the eyes, the nostrils and the M-shape markings at the top of the face.

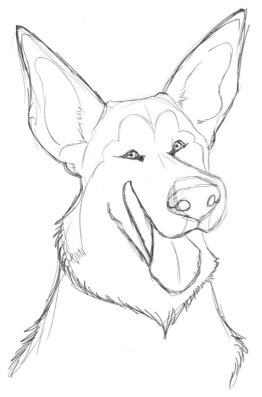

5 ADD DETAILS TO THE EARS

Because the ears are one of the main focuses of this caricature, we want to give them some special attention. Draw in a loose, curvy oval, following the contours of the ear. Mark off a small section near the tip of the ear; this area will be darker than the rest of the ear. At the base of the ear, draw a wide V shape to indicate the opening of the ear canal.

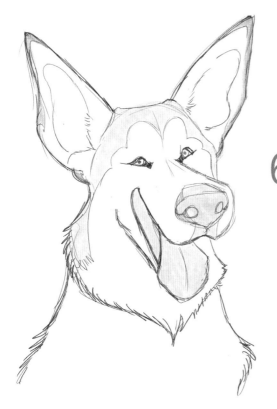

6 ADD THE FIRST LAYER OF COLOR

In order to play off of Blueberry's name, take a light blue color and shade the markings on top of and on the sides of the head and face. Color the sides of the mouth, or "flews," as they are called, and the nose. Don't forget to shade the tips and sides of the ears. Use a rose color for the tongue.

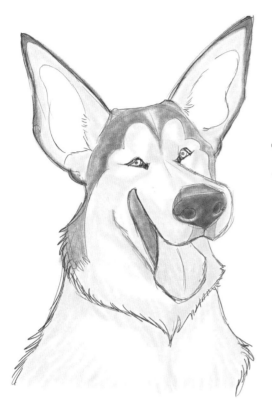

7 ADD SHADING

Take a medium blue and shade the areas where the markings meet the white fur in order to create a stark contrast. Leave some area white in the middle of the forehead because Blueberry has a light marking there. Color the nose and darken the nostrils. Pick a light blue-gray and shade the white fur around the eyes, inside the ears, on the muzzle and on the chest.

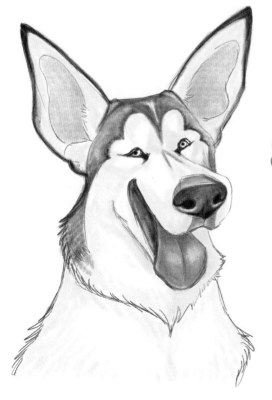

8 BUILD UP THE COLOR

Use a dark blue to darken the darker areas of the face, neck and ears. Use the same color to outline the eyes and darken the flews of the mouth. Use a medium rose color to shade the tongue, especially the part of the tongue inside the mouth because that area is cast in shadow.

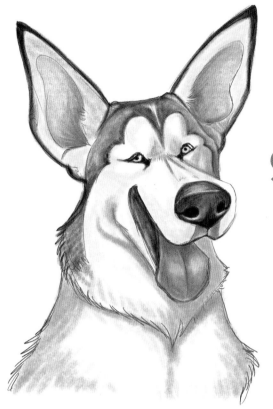

9 ADD MORE SHADING

Use a medium blue-gray to shade the areas of the white fur and darken under the chin, inside the ears and under the neck, where the fur of the neck and chest meet, as well as on the chest.

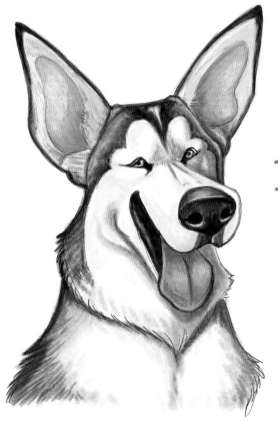

10 FINAL DETAILS

In order to blend the dark and light areas together, use a dark blue to make fur markings on the neck and the back. Blend these strokes with a swift motion to create the look of fur. Add an ice blue color to the eyes in order to make them pop. Blueberry's caricature is complete!

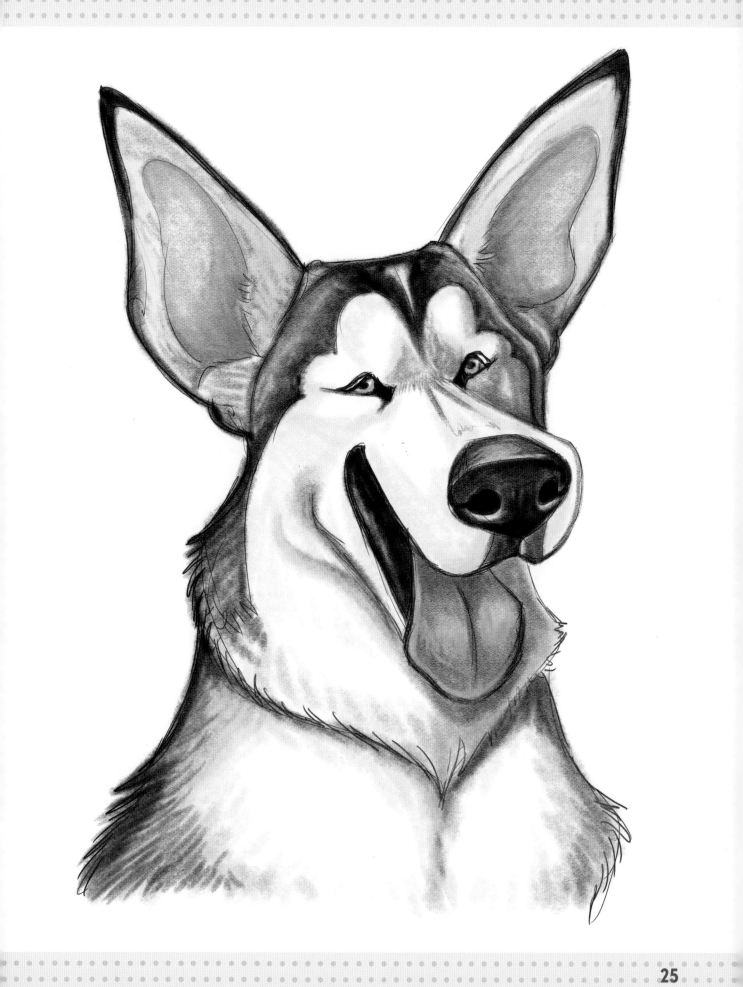

HONDO

Dogs are bred for all sorts of purposes—everything from helping on the farm to sitting on a lap. It's always fun seeing dogs excel at what they are bred to do!

Hondo is an Australian cattle dog, a breed bred for herding livestock in Australia. Cattle dogs are highly intelligent and have a lot of energy. If you don't have sheep or cows for this dog to herd, you will have a full-time job keeping one occupied!

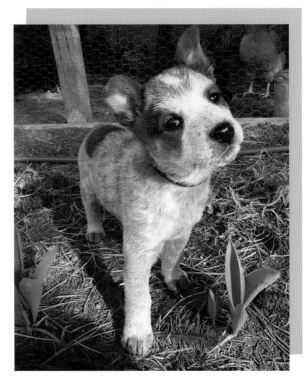

Hondo is a red speckled Australian cattle dog, which is a fancy way of saying that the fur has an even amount of reddish brown and white hairs growing throughout the coat.

1 SKETCH GUIDELINES FOR THE HEAD AND BODY

Start off by drawing a sphere for the head. Create a curved plus sign by drawing two lines that intersect in the lower right-hand side of the circle. Draw a smaller oval for the body below the main circle. Make sure the body oval is smaller in order for the head to be a little bigger in proportion. This will add the cute factor to the puppy's caricature!

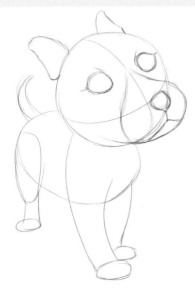

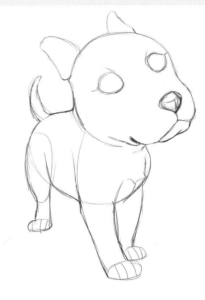

2 FINISH THE BODY GUIDELINES

Draw a teardrop shape on the front of the sphere; you will have to draw outside the boundaries. Sketch a small circle in the middle of the teardrop for the nose, then draw a wide, upside-down V shape for the mouth. Draw a line connecting the mouth and nose. Add two large almond shapes for the eyes. Draw the ears as small triangles on the top of the head. Draw cylinder shapes for the legs and small ovals for the feet. Finish with a small cone shape for the tail.

3 REFINE THE FACIAL FEATURES

Erase the guidelines on the face in order to better see the details. Refine the mouth lines and chin. Add lines to the paws to indicate individual toes.

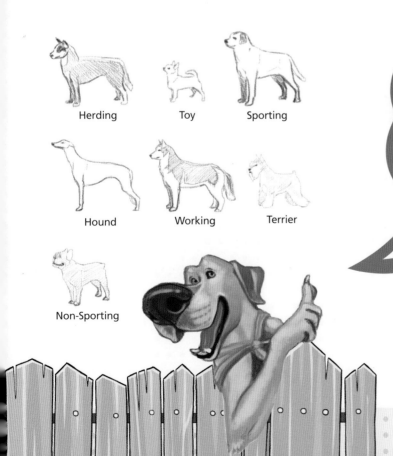

Herding

Toy

Sporting

Hound

Working

Terrier

Non-Sporting

There are seven main dog groups in the American Kennel Club. I am a Labrador retriever, and I am a part of the Sporting group, which is made up of dogs bred to hunt with people. Hondo is a part of the Herding group, bred to herd livestock for people. The others are the Toy, Hound, Working, Terrier and Non-Sporting groups.

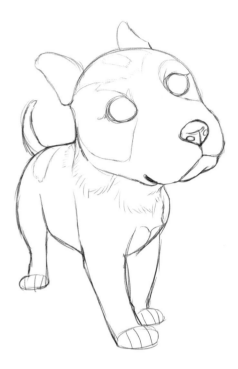

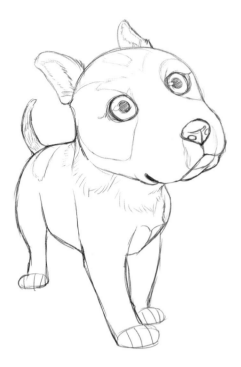

4 ADD THE FUR MARKINGS

Erase the guidelines on the rest of the body. Locate the markings on the reference photo and match them to the drawing. Sketch in furlike strokes to give the coat texture.

5 DRAW THE EYES AND OTHER DETAILS

Create the adorable look by drawing the pupils looking up. Even though the pupils are hard to see in the reference photo, adding them gives Hondo lots of character. Detail the inside of the ears with fur. Add the markings on the mouth and chin.

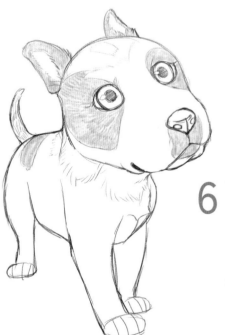

6 START ADDING COLOR

Choose a medium brown and fill in the darkest markings on the face, ears, mouth and body. This is the groundwork for the red-speckled look of the coat.

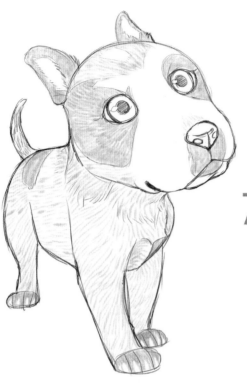

7 DRAW THE FUR TEXTURE

Using the same medium brown, sketch fur strokes following the direction of the hair growth. Generally, the hair tends to grow from the top to the bottom, starting at the head and moving down the sides and legs. Color in the feet as well, leaving small oval shapes white for the nails.

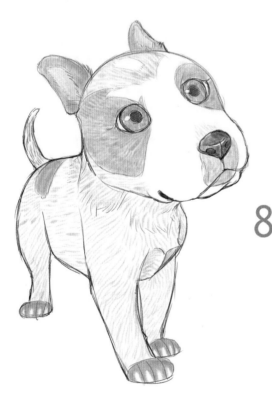

8 COLOR THE EYES AND NOSE

Pick a medium orange and color over the brown patches on the eyes, ears, back and feet. Use the medium brown to lightly fill in the irises of the eyes and darken the pupils. Choose a medium blue to shade the nose, leaving a white highlight between the top of the nose and the area where the nose turns downward.

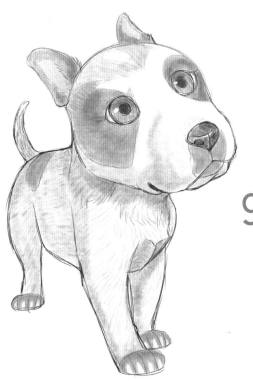

9 | ADD SHADING

Using the medium blue, lightly shade the areas of the body that are in shadow. If the light is coming from the right-hand side, the areas on the left will be in the shade, so the left side of the face, neck, legs, side and tail will be in shadow.

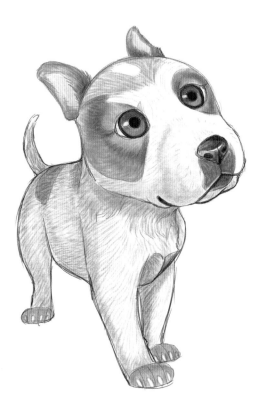

10 | FINAL DETAILS

Choose a lighter orange to go over all the brown markings. Follow the pattern on the fur in order to bring a realistic touch to the art. Lightly sketch the orange in the white markings of the face to show the texture. Choose a dark brown to draw focus to the eyes by outlining the irises and darkening the pupils. Select a dark blue to darken the markings on the nose. Finally, use the blue to lightly sketch in fur markings in the shaded areas to bring detail to the shadow. Hondo's caricature is complete.

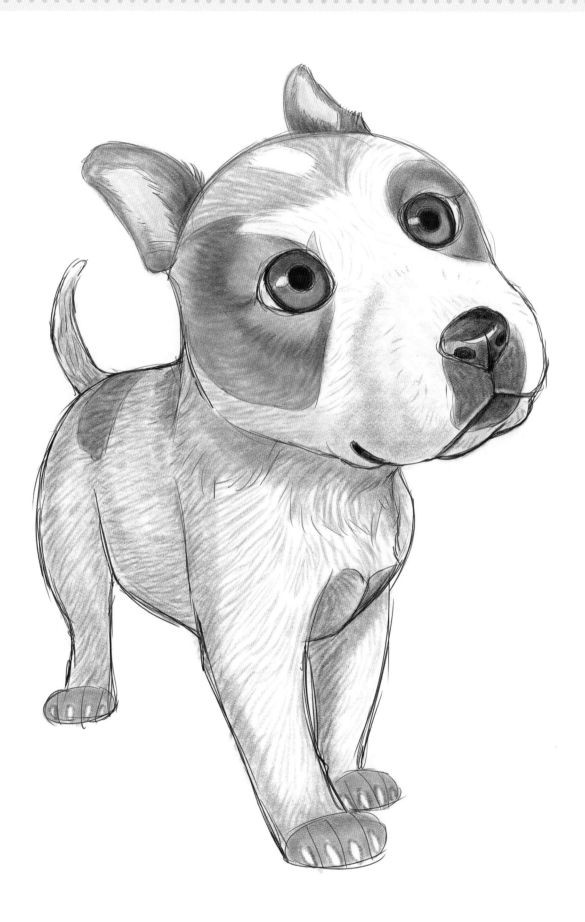

ZEUS

Not only have dogs been bred to have many different jobs, but many different looks too! Some of their looks help make their job easier or even serve as protection. English mastiffs were bred from dogs that were originally used to fight lions! It was said their wrinkly skin helped keep them from getting injured. If bitten, a lion would only get a mouthful of wrinkles.

Zeus is an English mastiff. They are one of the world's biggest breeds of dogs in terms of sheer mass. Other dogs are taller, but the English mastiff has them beat in bulkiness.

Zeus has a regal demeanor as he looks off into the distance.

1 SKETCH GUIDELINES FOR THE HEAD

Start by drawing a sphere. Draw a curved plus sign with the intersection located slightly to the upper left of the center of the sphere. This will set up the way Zeus looks slightly up and to the left.

2 DRAW THE NECK AND EAR GUIDELINES

Draw a large, wide teardrop shape, starting slightly above the intersection of the plus sign on the sphere. Create a triangle to the right for the ear. Next draw lines stemming down from the sphere for the neck.

3 DRAW THE FACE GUIDELINES

Draw two small circles for the eyes on either side of the teardrop shape. Then sketch a horizontal oval for the nose below the eyes, over the teardrop shape. From the bottom center of that oval, draw a short line down and then a wide, upside-down V for the mouth. Then draw two eyebrows over the eyes.

4 ADD CHARACTER FEATURES

Create shape on the top of the head by adding mountainlike triangles above the eyebrows. Draw the nostrils on the nose, and add some dimension to the muzzle with curved lines for the wrinkly mouth. Create some lines running from the eye down the side of the face toward the mouth to create more wrinkles there as well.

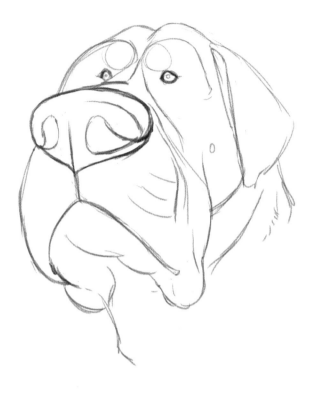

5 REFINE THE LINES

Erase the guidelines to prevent confusion.
Add pupils to the center of the eyes. Many
English mastiffs have a beauty mark, a
dot on the side of their mouths. Zeus is no
exception, so be sure to draw a small circle
for the beauty mark on the side of the face.
Make a few lines for the wrinkles on
the neck.

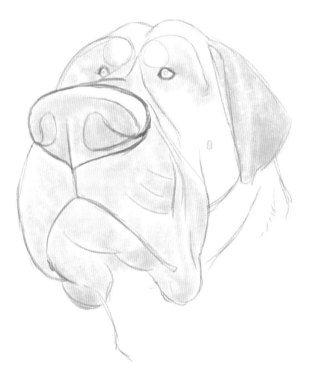

6 START ADDING COLOR

Select a light blue and shade the dark areas
of the face, the nose, the mouth, around the
eyes, the ears and the little beauty mark.

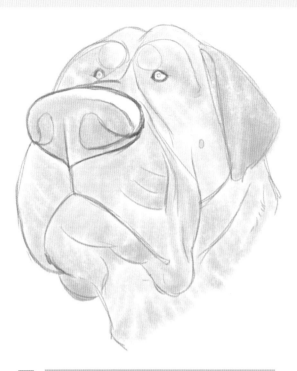

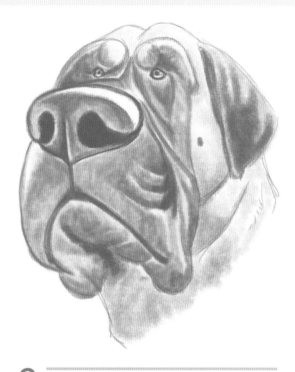

7 ADD MORE COLOR

Use a medium tan to fill in the remaining areas of the face, the top of the head, the sides of the cheeks and the wrinkles on the neck.

8 ADD SHADING

Choose a medium blue and outline the darker parts of Zeus's face: the outline of the nose, the nostrils, the line for the mouth, the eyes and the wrinkles. Shade the darker areas of the ear, leaving some areas lighter where the light is highlighting it.

To create wrinkles, leave areas of light next to areas of dark. This creates contrast, texture and a realistic look.

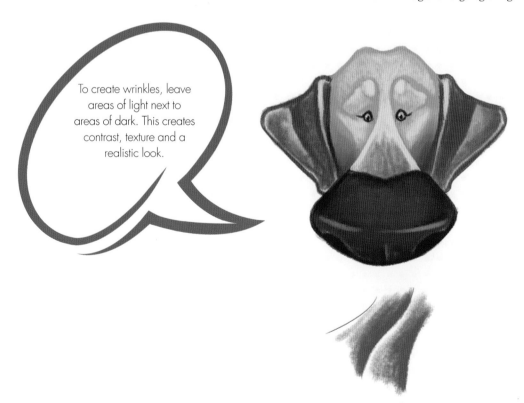

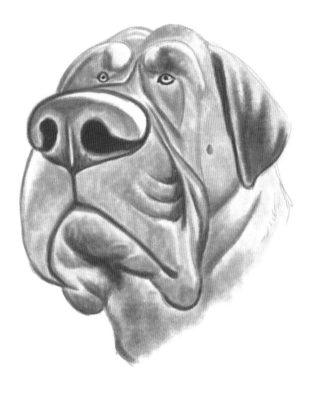

9 ADD THE DARKEST SHADOWS

Use a dark blue to shade in the very darkest tones of the piece, around the eyes, the pupils, around the nose and nostrils, the line for the mouth and the area between the head and the ears. Add shading to the neck. Choose a medium brown to shade the side of the face and neck.

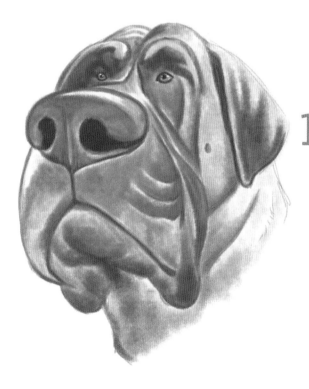

10 FINAL DETAILS

Use your medium blue again to blend the areas of darker blue together. Pick a medium brown to fill in the iris of the eyes. Use white to add reflection to the eyes. Your caricature of Zeus is complete.

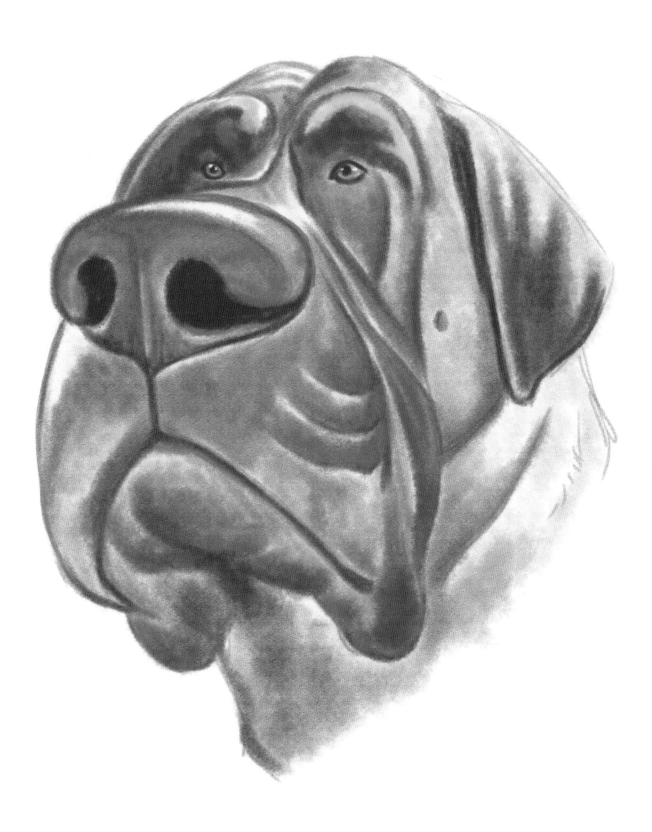

CAHLUA

Dogs are some of the most loyal, lively and lovable animals you will ever meet. They are also some of the most goofy and gross animals. Fortunately for most people, their individual perks outweigh their cons.

Cahlua is one of the three dogs that live with my family. She got her name from the Kahlua drink, since they both share a chocolate brown color. We changed the spelling to better match with all the names starting with "C" in my family.

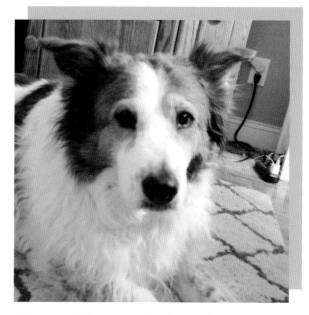

We believe Cahlua is a border collie mixed with Brittany spaniel. She has one of the most laid-back personalities of any dog we've ever met.

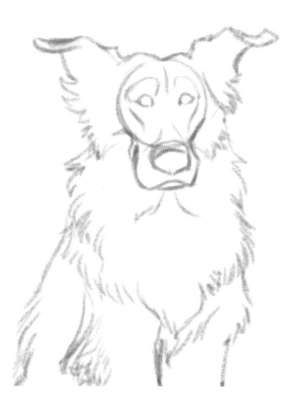

1 | SKETCH THE BASIC SHAPES

Start off by drawing a circle to indicate where the face will be located. From there, draw the triangular ear shape on the upper sides of the circle. Making the ears a little bigger than real life will give the artwork a caricatured look. Halfway down the circle, draw two small almond shapes for the eyes. Drawing the eyes smaller than they really are will make the nose and other features look bigger. On the bottom of the circle, add in the U shape that makes up the muzzle, adding in the mouth and oversized nose. In the seated position, the body makes a rough triangular shape. Make the body edges sketchy with lines for the start of the fur texture.

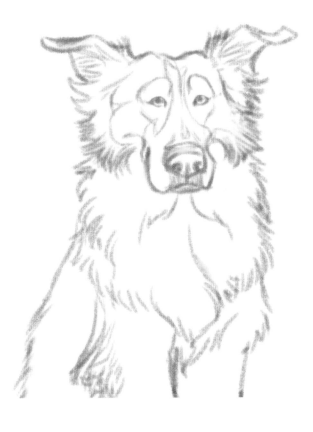

2 DRAW THE FACIAL FEATURES AND FUR

Cahlua has typical border collie fur, which seems to radiate in every direction. The fur starts in the center of the face and flows outward to the edges of the body. At this stage, you can add more details to the eyes, including the dog version of eyebrows, which are prominent on Cahlua's face. Add tufts of fur to Cahlua's cheeks, neck, chest and elbows.

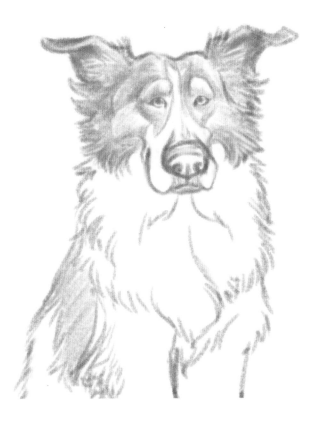

3 START ADDING SHADING

Lightly shade in the areas to define the facial markings and spot on Cahlua's back. Border collies typically have a marking called a "blaze" on their face, where white fur on the muzzle comes up and forms an inverted V shape on the nose, usually between the eyes. Cahlua is no exception to this strain of border collie genetics, so be sure to add this feature to her face.

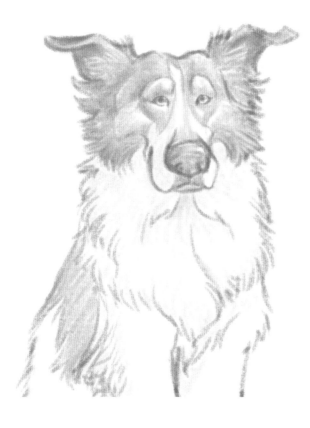

4 START ADDING COLOR

Take a light brown color and shade over the brown markings on the face and back. Use a light blue to add shading to the white fur on the left side of the face, under the muzzle and on the left side of the legs.

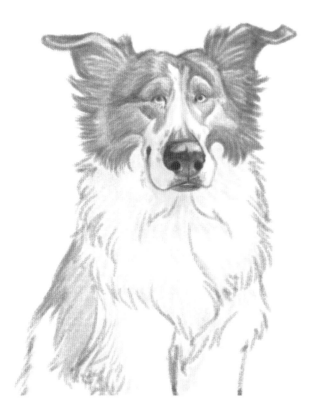

5 SHADE THE HEAD AND FACE

Use a more saturated (brighter) brown to add shading to the top of the head, ears and sides of the face. Color in the nose with a dark gray-blue to shade in the bottom and left-hand side of the nose. You can use the same color to shade in the area of the mouth below the nose and the bottom lip.

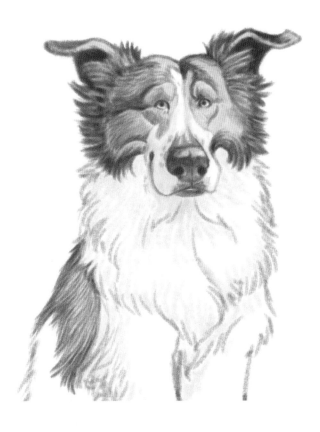

6 ADD DEEPER SHADOWS

Color in the deep shadows on the face and back with a dark brown. You can use this brown to color in small freckles around the nose and mouth as well. Blend a golden yellow color on the right side of the face to show the lighting.

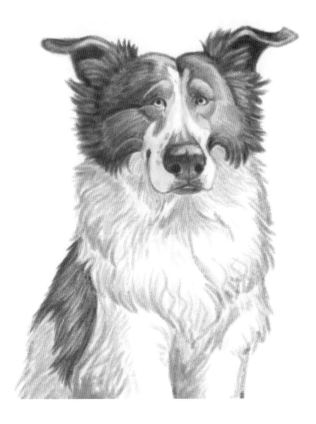

7 ADD TEXTURE TO THE FUR

Use a medium gray-blue to shade in more of the white fur along the muzzle, neck, side, chest and legs. Cahlua has ringlets of curly fur in the mane that makes up the white fur around her neck. You can depict this by drawing S-shaped squiggles with the darker color. It's okay if the squiggles intersect; they will give the fur a more layered, realistic look.

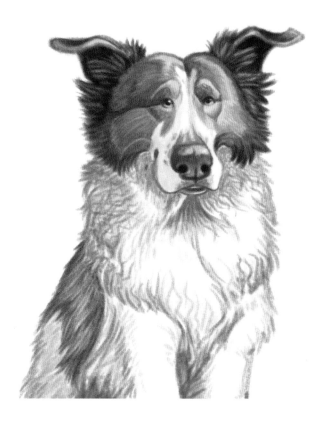

8 ADD MORE COLOR

At this stage, you can deepen the colors and add sheen to the coat by reintroducing the medium brown and going back over the darker and lighter brown on the face. Doing so will help unify the colors and blend them together.

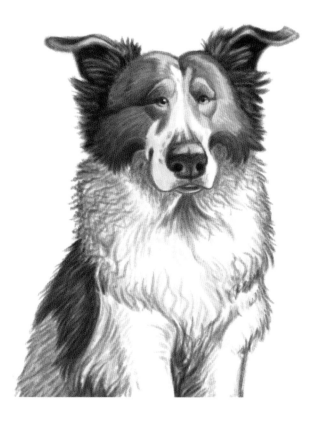

9 FINAL DETAILS

Add dark brown around the base of the ears and sides of the face where the fur is darker. Then use a dark gray-blue to shade the white fur around the left-hand edges of the neck and legs, making sure to use the squiggle S technique to build up the contrast and texture of the coat.

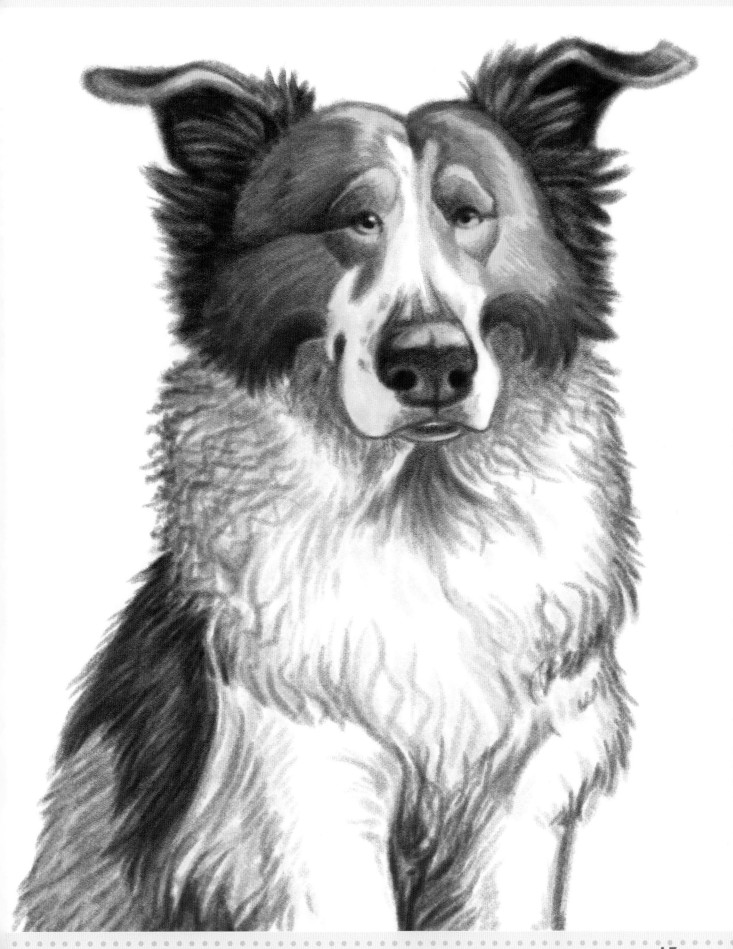

CATS

Cats are beautiful, playful balls of fur! They are relatively easy to care for and they are largely self-sufficient, which makes them a popular pet. More people have cats than any other type of pet.

CAT BREEDS

There are many different cat breeds. Cat breeds are not as strictly regulated as dog breeds, and one animal may be registered as more than one breed. However, most cats are not purebred and are instead generally called a domestic shorthair or a domestic longhair.

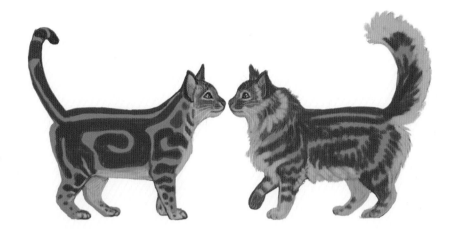

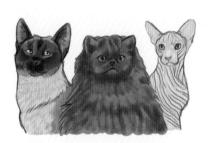

Breeds

Some of the best-known cat breeds are Siamese, Persian and sphinx. There are about fifty to seventy-five different cat breeds, depending on which organization you are consulting. Unlike most dogs, cats are largely bred for a certain look or personality trait and not necessarily to perform a specific task.

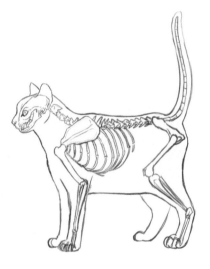

Anatomy

But for a few exceptions, cats tend to have similar body structures. They have small heads, and their bodies are of a rectangular build. Most breeds have long tails, though there are a few that are naturally bobbed or nonexistent.

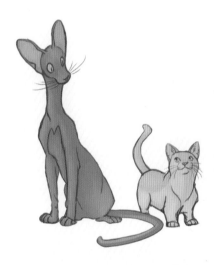

Unique Body Shapes

One exception to the typical cat shape, Oriental shorthairs have long and lanky legs and a narrower waist compared to most other cats. Another exception is the munchkin cat, which has shorter legs than other cats.

CAT FUR

Cats are most often distinguished based on how much hair their coats have (or don't have!). They can be broken up into short-haired, semi-long-haired and long-haired cats.

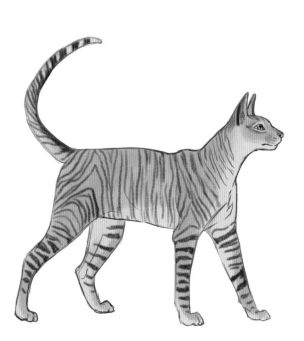

Shorthair

Shorthairs come in a variety of sizes and shapes, but all are distinguished by their coats of fur, which can be thick but does not grow longer than a couple of inches. Short-haired cats are the most common cats in the world.

Semi-long

Semi-longhairs are cats with shorter hair on their face and back, but have longer hair on their neck, stomach and tail. The hair is less thick and not quite as long as long-haired varieties. There are a few breeds that are considered semi-longhairs, such as the Turkish Angora.

Longhair

Longhairs have fur that is 3-4 inches long nearly everywhere on their bodies, including cheeks, neck, stomach and tail. The fur is plush and thick, and insulates them from the cold. It is believed that some breeds were once longhairs from the wild, such as the Norwegian forest cat.

Fur Texture and Patterns

Cat fur comes in a wide variety of colors and patterns. They can have spots, stripes or solid colors. Some patterns are restricted genetically primarily to female cats, like tortoiseshell and calico. Other patterns are restricted to certain breeds; for example the Siamese is always seal pointed, which is to have a dark color on the ears, face, feet, legs and tail.

WHAT TO EMPHASIZE

Not only do cats have varied looks, but they are dynamic creatures with unique personalities. Some are quiet and shy, some are bossy and loud, and others are total cuddle bugs! Whether drawing from life or imagining your own cat character, observe from life and see the personalities of the different cats around you. Expression plays an important role when basing a caricature on the animal's personality.

Happy

Cats show that they are happy by closing their eyes, slowly blinking, curling up in a ball to lay down or sitting on something you need to use. They will also purr and knead their paws to show affection.

Scared

Cats get scared for many different reasons. Loud noises, unusual scents or smells and unexpected surprises can elicit a fear response. Cats show their fear by retreating to a small space, such as under a bed, or they will attack by arching their backs, puffing out their tails to look bigger and batting with their claws. They may also growl, spit or hiss.

Playful

Kittens and cats have a playful streak in them. Many toys are made for cats to encourage them to be active and to interact with their humans. Cats are incredible athletes and are capable of jumping, twisting and even flipping in the air. These dynamic poses are a great way to show your cat's personality!

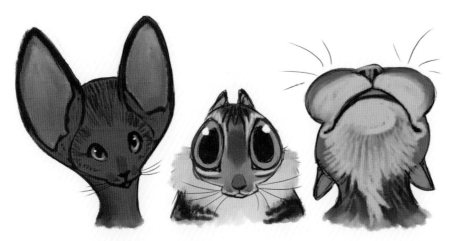

Exaggeration

Some cats have unique physical features, such as big ears, large eyes and flat mouths that are great to draw attention to. It's important to draw less attention to other areas of the caricature in order to make the area you want to emphasize stand out. Just be careful that you don't take it too far.

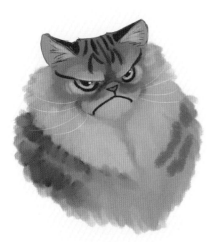

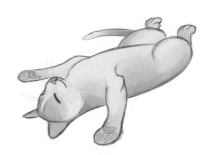

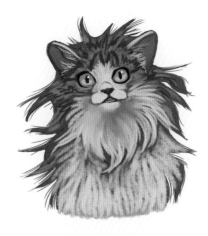

Expressions

Cat faces can be a great source of inspiration when it comes to deciding what to emphasize. Perhaps it's a little kitten looking up with its huge eyes or a scowling Persian. There are plenty of key aspects to the feline face worth featuring!

Poses

Cat bodies are flexible and can be warped in a variety of poses. Some cats enjoy sleeping flat on their backs with all four limbs splayed. Other cats may be large but they can fit inside a little box.

Fur Personality

Coat patterns, fur and even "bad hair days" can be great things to feature in your cat cartoons. Maybe your cat woke up on the wrong side of the bed or ended up grooming itself a cowlick. Be sure to incorporate a story to add more interest and humor to the artwork.

TOM

Now that we have learned a bit about the different types of cats, what they look like and how to find the best features to enhance, it's time to do a caricature of your cat.

It's best to get a few reference photos of your cat. Choose a pose that best captures the pet's personality. Is your cat big and brave? Or small and timid? Or even big and timid? Contrasts provide more humor in your caricature, so it will make for a more interesting piece.

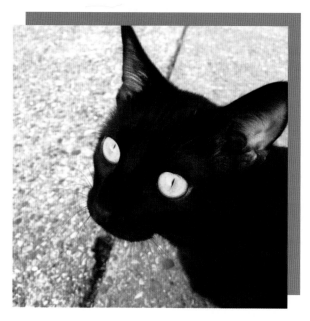

Tom is a cute black kitten, full of energy and personality!

1 SKETCH THE HEAD GUIDELINES

Start off your drawing with a circle indicating where you want the head to be. This step helps determine the composition from a very early stage. Draw a curved plus sign on the face to indicate where the face is pointing; in this case, to the lower left side of the page.

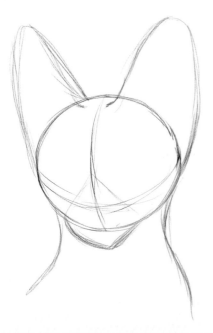

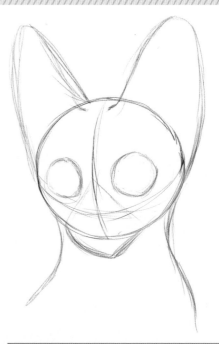

2 DRAW THE EARS AND NECK

Create the ears by drawing two rounded triangles at the top of the head. Because this is a kitten, the ears seem a little too big for the body. You can emphasize this trait by drawing oversized ears. Draw in the neck, making it slightly thinner than the head, to add the kitten-esque appearance. Finally, sketch in a rough diamond shape to indicate where the muzzle will be. Have the bottom part of the diamond protrude past the circle for the head to indicate the direction the kitten is looking.

3 DRAW THE EYES

Lightly sketch in circles above the horizontal guideline to serve as placeholders for where the eyes will go. Keeping your sketch light at this stage will help you to either draw or paint over it or make it easier to erase your guidelines in later stages. Kittens have big, illuminated eyes, and you want to show this by making the circles slightly bigger than what you see in reality.

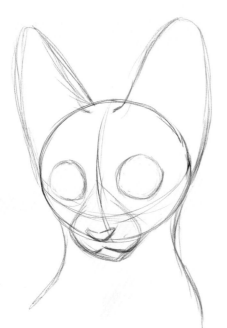

4 DRAW THE MUZZLE

Continue the sketch by drawing in the muzzle and nose. Just as you made the ears and eyes oversized, you can make the mouth and nose smaller than real life to help contrast the features.

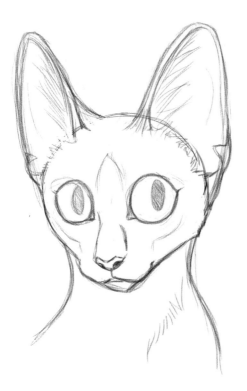

5 ADD DETAIL TO THE LINE WORK

Finish the sketch by filling in the details. Create the ear rim by drawing an inner line around the outer edge of the ear. Add the wispy fur inside of the ear along the top edge of the inner ear. Indicate fur along the border where the ear and the top of the head meet. Draw almond-shaped eyes and oval-shaped pupils looking off to the side to give a mischievous expression. Use part of the horizontal face guideline to create the cheekbones under the eyes. Add to the coy expression by creating a little smirk on the muzzle. Erase the guidelines to finish off your sketch.

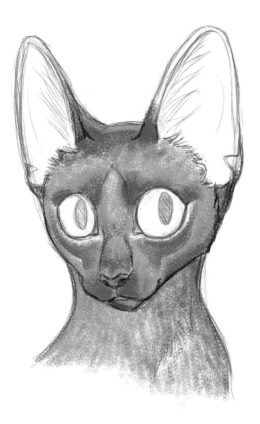

6 START ADDING COLOR

Start to add form to the caricature by adding color. Use a blue or purple base for coloring black animals. This helps bring out their features and creates a more compelling illustration than simply sticking to all blacks, whites and grays. Choose a medium blue and look at the reference photo to see where the darker spots are located: above and under the eyes, on the top of the head and below the nose. Add a lighter blue to the forehead, in between the eyes, on top of the nose and under the cheekbones.

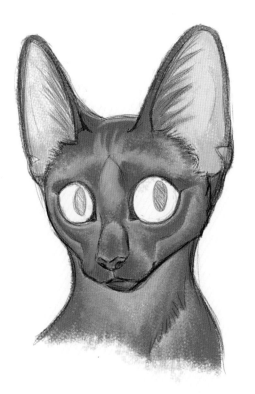

7 BUILD UP THE COLOR

Continue to add shades of light and dark blue to the appropriate areas, as shown in the reference photo. Contrast areas of light next to areas of dark to help make the caricature appear more realistic. Choose a light rosy pink for the inside of the ears.

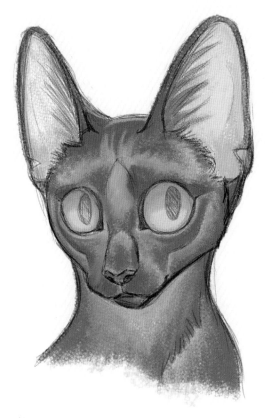

8 COLOR THE EYES

The light is coming from the upper left-hand side of the piece, so the fur over the eyes is casting a shadow on the rounded surface of the eye. To add the shadow from the fur, use a medium gold-yellow around the top half and bottom edge of the eyes. Color the remaining parts of the eyes with a light golden-yellow.

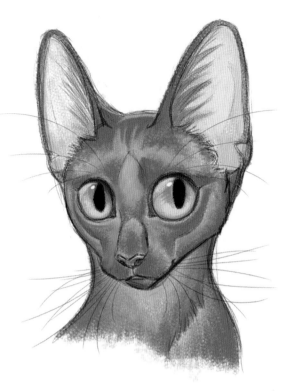

9 FINISH THE EYES AND ADD WHISKERS

To complete the eyes, choose a dark blue or black and fill in the pupil. Add a white highlight to the upper left-hand side of the eyes. Add a glossy shine to the upper left-hand side of the eyes by choosing a white and highlighting the area transparently so the gold still shows through. Further blend the gold colors together to help create depth. Don't forget to add the whiskers under the nose and above the eyes!

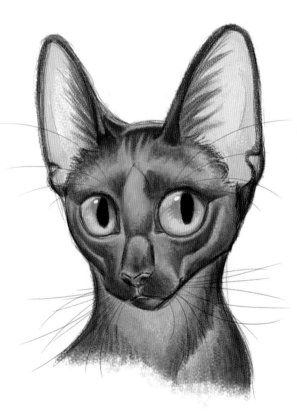

10 FINAL DETAILS

In order to help make the piece pop, add a dark blue tone to the shadowed areas of the caricature: on the top of the head, around the ears, under the eyes and beneath the nose. This pumps up the contrast, makes the piece more visually appealing and helps create a realistic effect in your work. Keep the animal's personality in mind throughout the creation of the artwork to help inject life and humor into the caricature.

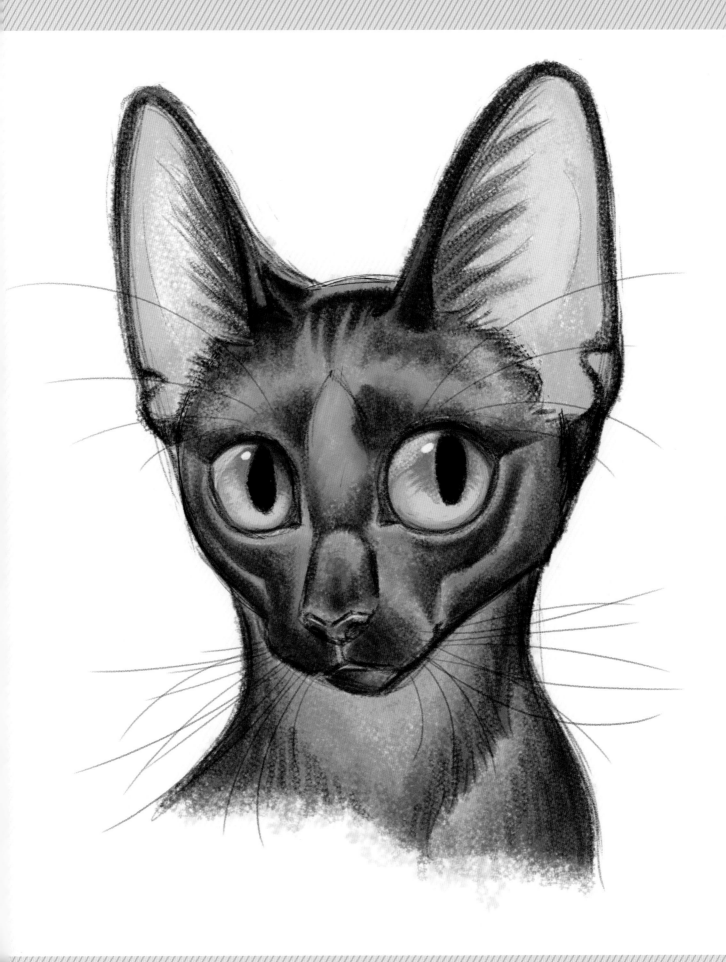

TRIXIE

There are times when the pose in a photo doesn't quite match up to what you want to draw. After drawing a few illustrations of cats, you will have the experience needed to create your own pose.

Trixie is a tortoiseshell shorthair. Tortoiseshell is a coloration that is made up of a unique pattern of black, orange and some white hairs. These cats are special in that only female cats carry the tortoiseshell gene.

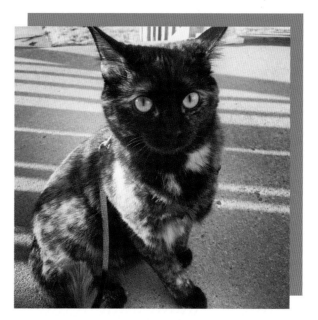

Sometimes pets are hard to photograph in the perfect pose and harder still to draw from life doing much else other than sleeping! Armed with your knowledge of feline anatomy, you can draw any cat as long as you have a general idea of what it looks like.

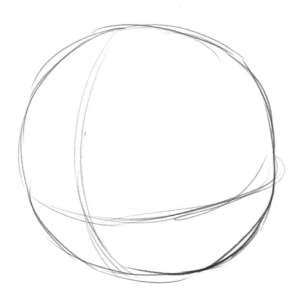

1 SKETCH THE HEAD GUIDELINES

Start by drawing Trixie's base head shape as a sphere. In the photo, she is looking downward slightly. Draw a curved plus sign intersecting the face so the two lines meet near the bottom left-hand edge of the circle.

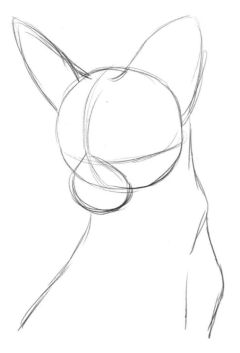

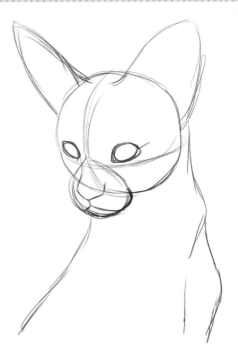

2 SKETCH THE EARS AND BODY

Now that you have the base for her face, you can draw in the triangles for her ears. Make the triangles oversized to add some humor to the caricature. On the bottom of the plus sign made for the face, draw a teardrop shape, making sure some of it sticks out of the sphere to show the muzzle. Sketch in the line for the back and the lines for the neck and chest.

3 DRAW THE EYES AND MUZZLE

Draw almond shapes for the eyes on either side of the muzzle's teardrop shape. From the corners of the eyes, draw two lines toward the bottom of the teardrop shape. These will be the sides of the nose. Draw a triangular shape on the end of the two lines. Then sketch in an upside-down V shape for the mouth, connecting a line from the mouth to the bottom of the nose.

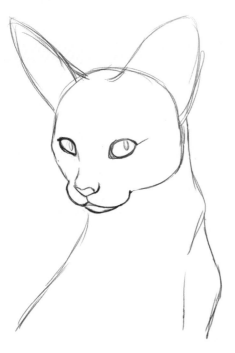

4 ERASE THE GUIDELINES

After you have the base forms sketched out, you can erase the guidelines. Complete the top edge of the nose, making a shape similar to a heart. Draw two small almond shapes for the pupils of the eyes. Having the pupils looking at the audience will make the cat appear a little sly.

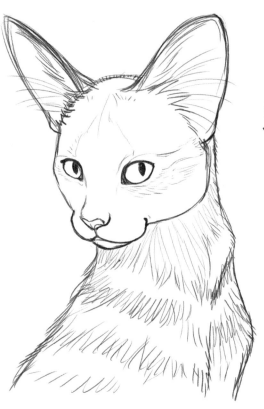

5 FINISH THE LINE WORK

Add a little smile to give the feline an even more playful look. In order to know where the lights and darks go for the tortoiseshell markings, pay attention to the reference photo. Lightly indicate which areas of the face have light and dark markings.

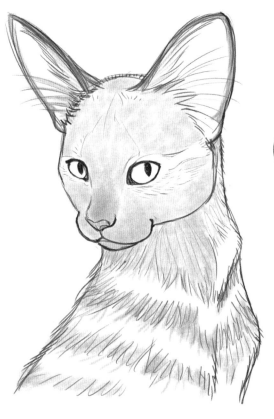

6 START ADDING COLOR

Select a light blue-gray color and shade in the dark areas of Trixie's coat. You can color the rims of the ears darker because there are no lighter markings there. Adding colors in stages builds up the texture and creates the look of real fur.

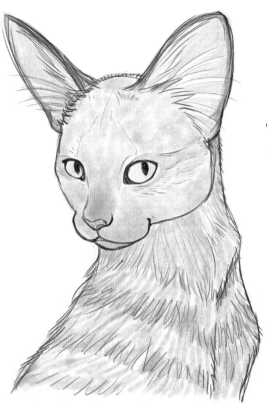

7 START THE TORTOISESHELL MARKINGS

Pick a medium brown or dark orange and shade the areas where the orange tortoiseshell markings are. Choose a rose pink color to fill in the inside of the ears. Next select a light yellow to fill in the color for the eyes.

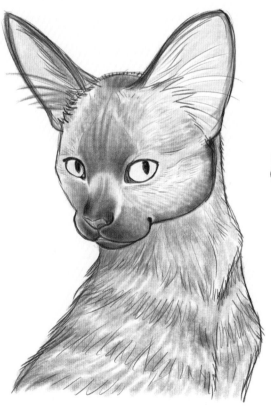

8 ADD SHADING

Use a medium blue-gray to shade the areas that are darker, such as the top of the nose, in between the eyes, the area below the nose and along the back.

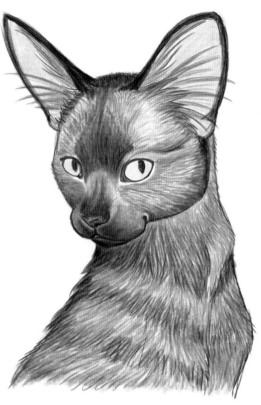

9 BUILD UP THE COLOR

Choose a dark blue to continue shading in the darkest parts of Trixie's caricature. Use short strokes in the direction the fur grows in order to create the fur texture. Select an orange to add in the tortoiseshell colors. Mix them with the dark blue to create a blended look.

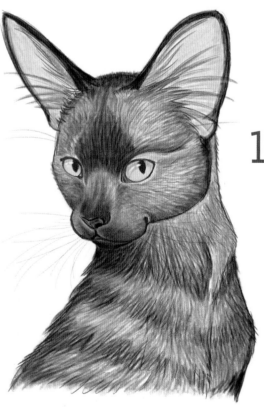

10 FINAL DETAILS

Choose a medium blue-gray to lightly shade over the darker areas. This will help blend the black and brown tortoiseshell markings together. Pick a medium yellow to shade in the top half of the eyes to create a shadow. Add white reflections to make the eyes sparkle. Finally, add the whiskers. Trixie's caricature is complete.

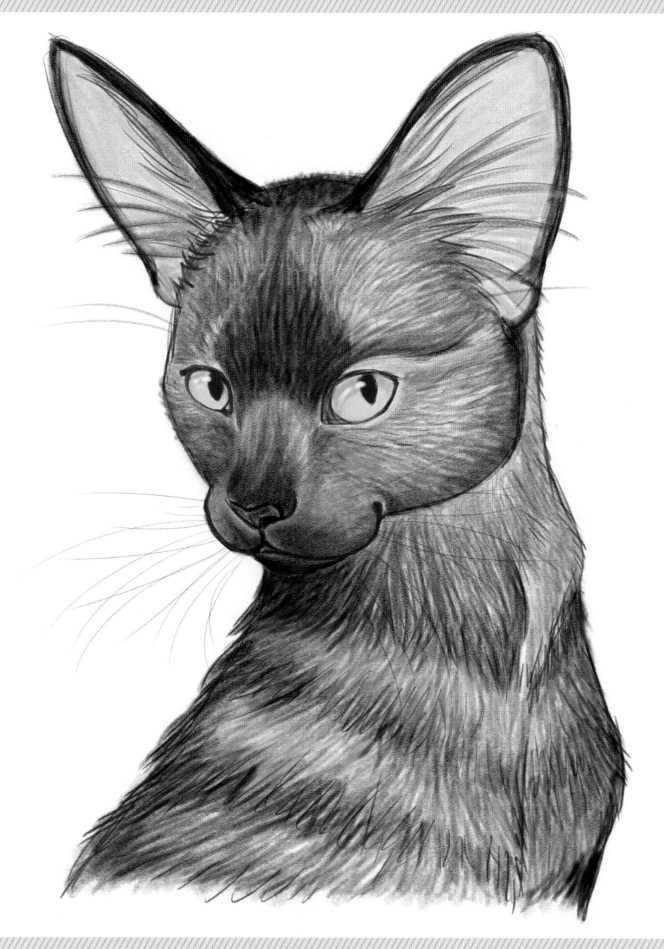

CHARLIE

Cats come in so many different shapes, colors and patterns. It's fun to research all the different types of markings and learn the names of each one. There is an amazing variety!

Charlie is an orange long-haired tabby with great features. Each cat is unique, so it's important to study the reference photos to make sure you are drawing the markings correctly.

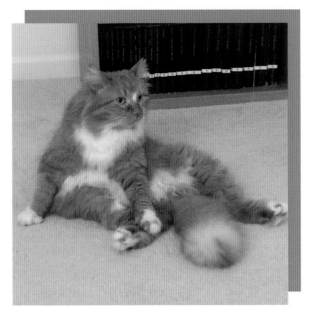

Capture your pet striking an amusing pose. In Charlie's case, the picture of him sitting on his right hip with his back legs sticking out does much to show off his laid-back personality.

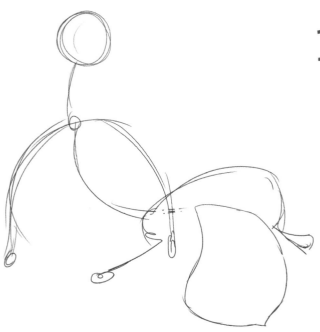

1 DRAW GUIDELINES FOR THE POSE

With unusual or challenging poses, it is helpful to break the pose into simple circles and lines. Start with a circle for the head. Next follow the "line of action," which typically consists of where the main part of body and spine are going. Charlie's back is in a loose C shape, ending with his big teardrop-shaped tail. The front legs make an n shape, and his back legs are splayed out. Draw two lines indicating the back leg between his front paws and another line for his leg on the other side of his tail.

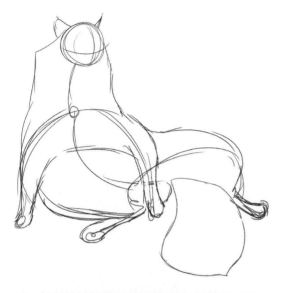

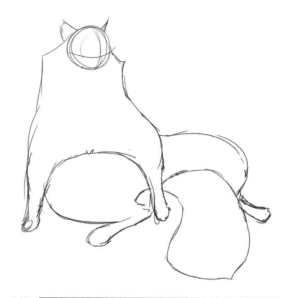

2 SKETCH THE OUTLINE

After creating the lines as a base, you can add form to the figure by sketching Charlie's outline. Because he is a fluffy cat, the overall shape is going to be larger than a short-haired cat. Draw lines connecting the head to the front paws. Then use sweeping curved lines to draw the back legs. Finally, draw two small triangles for his ears.

3 ERASE THE GUIDELINES

Erase your guidelines at this stage in order to better see Charlie's form and features. Keep the guidelines for the head because this will help when drawing the facial features.

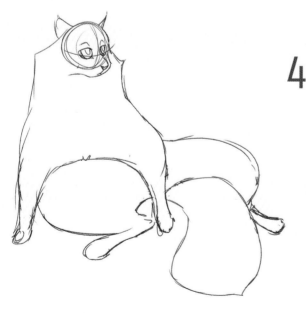

4 DRAW THE FACIAL FEATURES

In order to give Charlie a complacent expression, draw in the circles for his eyes, then draw a horizontal line halfway across those circles. Erase some of the upper circle and leave some of the line in order to give his eyes a droopy look. Draw a sideways u shape for the mouth and nose. If you draw his mouth smaller than it looks in real life, you will complete the disinterested attitude.

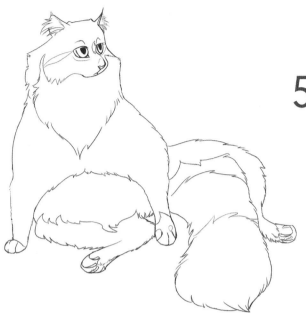

5 FINISH THE LINE WORK

Once the face details are added, erase the guidelines for the head. Draw in the fur pattern and texture. Long-haired cats tend to have a "manelike" appearance, and you can emphasize this with a V shape going from the neck down to the front legs. Draw the circular paw pads and lines that separate each toe.

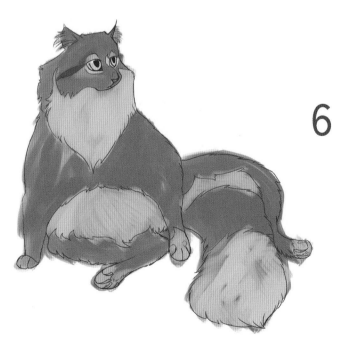

6 START ADDING COLOR

Choose a medium orange-brown for the base of the coat. Next pick a cream color to fill in the markings on the face, neck, stomach, feet and tip of the tail. Use a golden-yellow for the eyes.

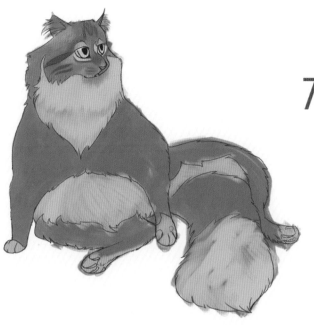

7 START ADDING STRIPES OF FUR

Use a dark brown to start adding the stripes on the face. The markings right above a tabby cat's eyes almost always create an M shape. Draw an M above Charlie's eyes, and add the stripes on the side of his face and under his eyes. Keep the details a bit loose to create a more cartoony caricature.

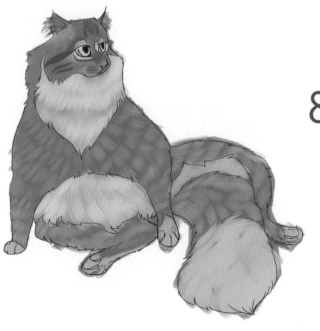

8 CREATE THE FUR TEXTURE

At this stage, start using a lighter orange color in circular patterns around Charlie's body. This is the start of detailing the fluffy fur that makes up his coat. Use a lighter cream and do the same on his neck, stomach and tail.

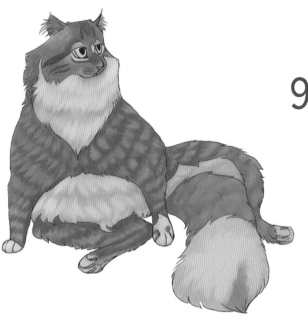

9 ADD SHADOWS

Under the lighter orange tint, add a medium brown to indicate shadowing. Form pointed V shapes to depict the fur texture. Use a medium cream below the lighter cream to add shading on the neck, stomach and tail as well.

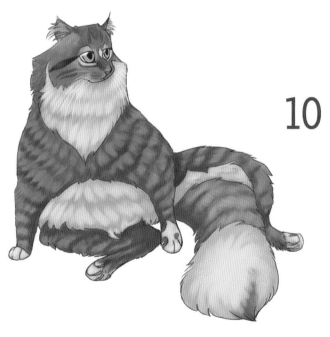

10 FINAL DETAILS

Finish Charlie's caricature by choosing a dark brown color to continue shading the medium brown areas. This will create a layered look that will add a realistic touch to the portrait. Finally, use a medium pink for the nose and paw pads, completing the artwork by using white to add the droopy whiskers.

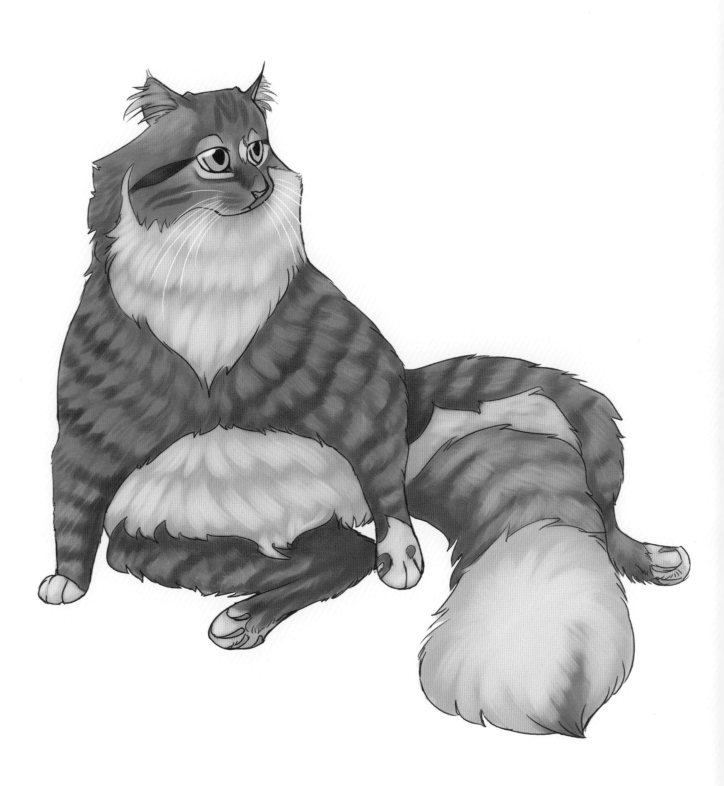

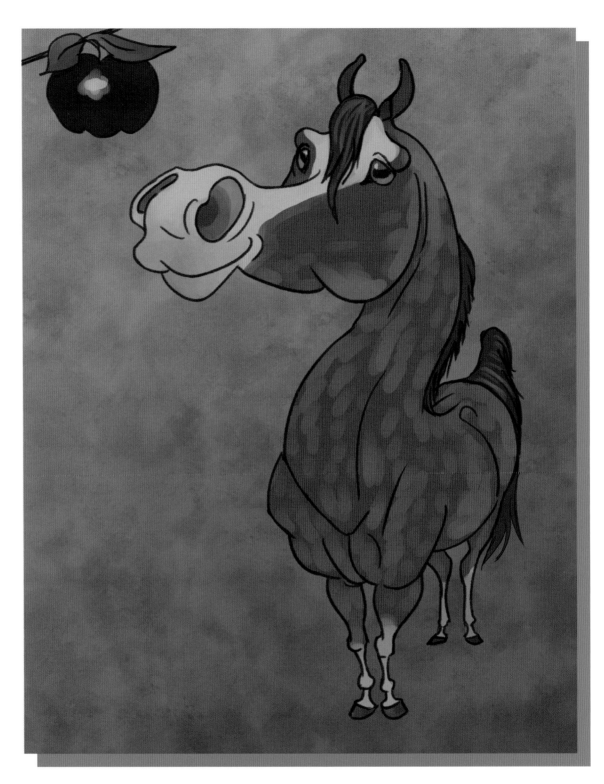

HORSES

Horses are some of the most graceful, elegant animals. People the world over love horses for their strength, speed and beauty. Humans have forged a relationship with horses for the past five thousand years.

HORSE ANATOMY

There are more than 350 different breeds of horses, ponies and wild equines, and though you can find some differences in height, body type and personality between breeds, all horses share similar traits. They are mostly large creatures that have long faces and necks, round bellies and thin legs. Keeping these features in mind will make it easier to caricature a horse and play with the proportions, making your cartoon believable.

Face Shape

When drawing a horse's face think of the head generally as a cone shape. The part of the head nearest to the neck is the widest, and the mouth is the smallest. The cheeks are similar in shape to rectangles, and the muzzle is similar to a cylinder.

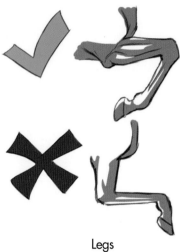

Legs

A horse's legs are its most important feature. The legs are what allow it to fight or, more commonly, escape from danger. A horse's front legs are different from a dog's in that they have a knee that bends forward in front of the shoulder, never backward. The rear legs are more similar to a dog's in that they have hocks; however, the feet end in hooves, not paws.

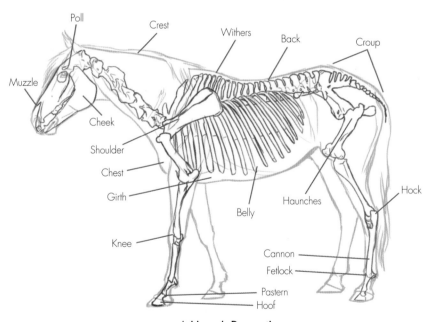

A Horse's Proportions

Almost every area on a horse has a specific name. The above chart shows some of the most crucial terminology to remember. Proportionally the horse's head is about the same length as the neck, and the head length plus the neck length equal the same length as the area from the horse's withers to its hooves.

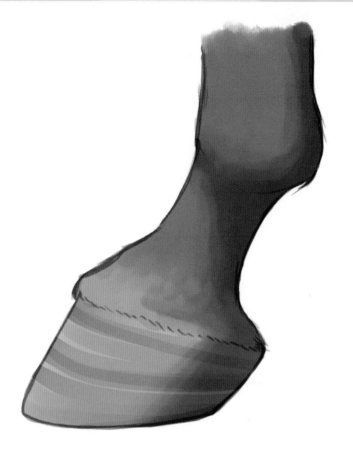

Hooves

Hooves are essentially the horse's fingernail. Horses are known as odd-toed ungulates (hoofed mammals), which means they have an odd number of toes. In a horse's case, their hooves are only one toe. Hooves are special in that there is a hard exterior wall protecting the nerves and bones within. A hoof is like a fingernail in that it will continue to grow throughout a horse's life. Special people called "farriers" trim horses' hooves to keep them from growing too long.

Mane and Tail

Distinctive features include the mane and tail. Horse hair is coarse, and the hair is usually straight, though some breeds, like the Andalusian, are known for their wavy manes and tails. The hair is the same on the mane and the tail. Some horses have feathering over their hooves, a lighter, softer fur, similar to what is found on a horse's body. A horse's mane starts at the forehead (also known as the forelock) and goes down the top of the neck, or crest, to the withers. The horse's tail is only about a foot from the horse's spine. The tail hair can be much longer than the bone. Remember to draw the tailbone first, then hair coming off from it. Horse tails are not just made up of hair!

DIFFERENT DISCIPLINES

There are two distinct types of riding in the horse world, English and Western. Many similarities exist between the two; the main differences are in tack and the purpose behind the discipline. English riding stems from England and has a long history. It consists of very specific terminology and communication between horse and rider. Distinct disciplines within English riding include dressage, jumping and cross-country eventing.

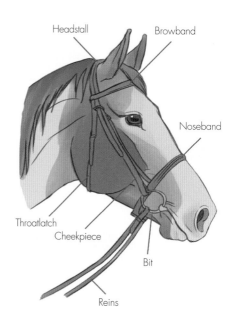

Tack

Anything that humans use on a horse is generally referred to as tack. Bridles are a specific type of tack that goes on the horse's head. English bridles are typically more complex than Western bridles. They are different styles, depending on the discipline. Halters are another form of tack that goes on the horse's head, but a halter is generally only used to lead a horse from one place to another. Then it is removed, and a bridle is put on in order for the rider to better control the horse when riding.

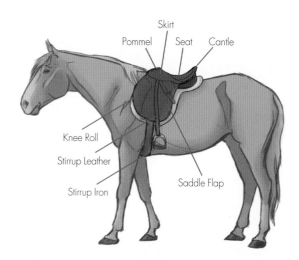

English Saddle

The English saddle is a formfitting saddle that allows the horse freedom of movement in the various activities that riders require. Dressage saddle flaps are longer to allow more contact between the rider's leg and the horse's side. A jumping saddle is smaller to allow the horse to use its whole body when going over jumps. A racing saddle is smaller still and only serves as a place for the jockey to brace himself while the horse is running.

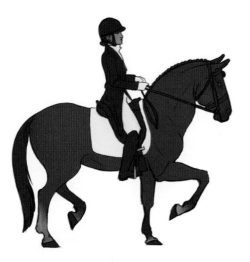

English Riding Style

The English riding style is seen as very proper and elegant. The style tends to accentuate the most impressive aspects of the horse's movement. Typical English riding style involves the rider rising up and down out of the saddle when trotting or cantering with both hands holding the reins. The upper body is straight, if not slightly tipped forward, with the legs and feet in alignment.

Western riding came about in the 1600s, when settlers in the Americas were traveling westward. They needed a saddle that would be comfortable for the horse and rider for very long durations of time. Western riding has expanded to several specific disciplines, such as reining, cattle cutting (keeping one cow away from the herd) and barrel racing.

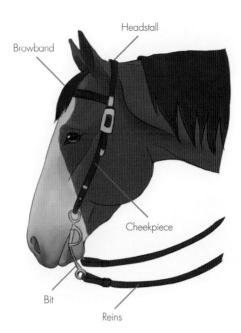

Western Bridles

Western bridles are more utilitarian; they are less focused on precise control over the horse and more focused on ease of use putting on and taking off. In many cases, they lack the noseband of English bridles. Some Western bridles are known as a "one-ear headstall" because the browband wraps around only one of the horse's ears.

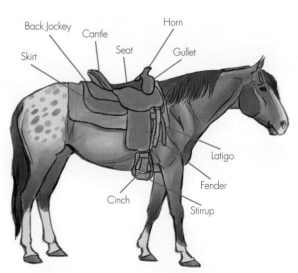

Western Saddle

The Western saddle expanded in size in order to be more accommodating to the rider and to allow the rider to travel with more items attached to the saddle. Most of these extra pieces allow for baggage to be tied to it.

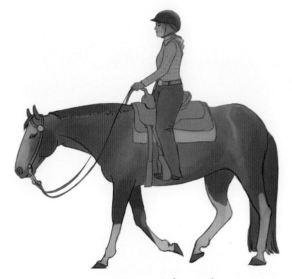

Western Riding Style

Western is largely seen as a more relaxed riding style than English. Many people who want to go on trail rides use Western tack. Riders tend to be more deeply seated in a Western saddle, though their upper body, legs and feet must still be in alignment. Western riders also generally hold the reins in only one hand.

ACTION SHOTS

Horses are incredibly fast and are capable of many different movements. They tend to have four different gaits or speeds, though some breeds have specialty gaits. The four main gaits are the walk, trot, canter and gallop, with each gait increasing in speed.

Dynamic Poses

In order to create an interesting cartoon with a dynamic pose, it helps to follow an action line. This line follows the general movement of a figure from the head to the feet. Using one creates a flow and fluidity within the piece that people will appreciate and gravitate toward.

Horses have different ways of getting around compared to us dogs! They can walk, trot, canter and gallop. Here is an example of each!

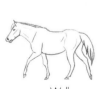
Walk

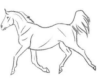
Trot

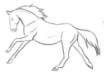
Canter

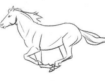
Gallop

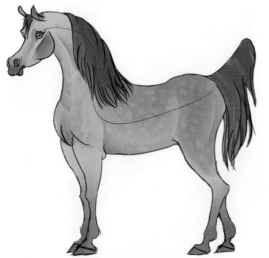

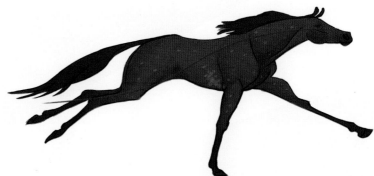

Standing

By following a fluid action line, even more static poses like standing will look more elegant and regal. Start with a sweeping action line, then use your knowledge of horse anatomy to exaggerate the proportions and make an interesting cartoon.

Running

Horses are probably most well-known for their ability to run. In order to create a funny cartoon, you can greatly exaggerate the limbs, extending them far out in front of the horse to make it look like the horse is moving really fast!

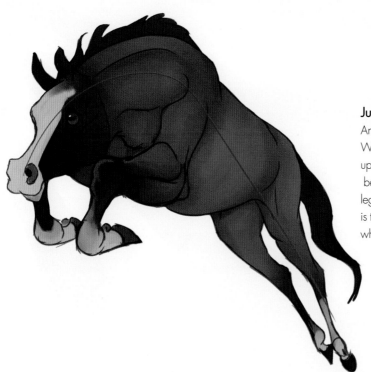

Jumping

Another area in which horses excel is jumping. When a horse jumps, it typically tucks its front legs up under itself, creating a unique pose that can be fun to caricature. You can really squish a horse's legs together to make it look like the horse is trying really hard not to knock into anything while jumping!

MICHAEL

There are many breeds of horse, and they come in many different shades, patterns and colors. Paint horses can come in multiple colors, but they are known for the big white patches on their bodies.

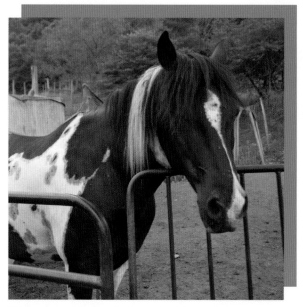

This horse is a black-and-white paint. No two paint horses have exactly the same markings.

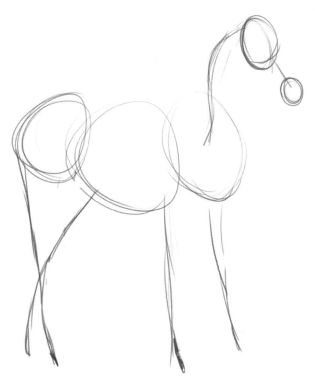

1 DRAW THE GUIDELINES

Drawing the full body of a horse can be complicated, so the best approach is to break down the form into steps. Start with a circle for the main part of the head. Slightly below and to the right, draw another smaller circle. Connect the circles with a line; all of this forms the head. Next draw a slightly curved line, approximately the same length as the head, from the top of the first circle down toward the center of the page. Draw a circle around the bottom of that line, which will form the shoulders and chest. Create a larger circle to the left of that for the belly. Next draw a smaller circle to the left of that, creating the haunches. Draw lines stemming down from the circles, indicating where the legs will go.

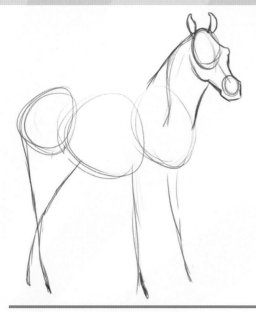

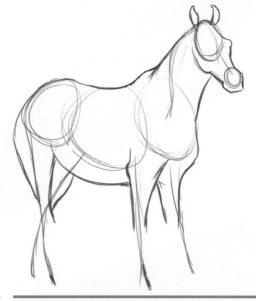

2 REFINE THE HEAD SHAPE

Start filling in the head shape by drawing a line from the top of the head down toward the shoulder circle; this will form the top of the neck. Study the reference photo and draw the outline of the face using the circles as a guide. The far eye will stick out in a slightly triangular fashion and then dip back in to form a narrow nose. The bottom jaw is large and rounded. Connect the jaw to the nose with a tapering line, leading up to a squared-off mouth. Draw the ears as narrow D shapes. Finish off this step with a line going from the large round cheek down toward the shoulder circle.

3 CONTINUE DRAWING THE BODY OUTLINE

In order to make this horse more of a caricature, draw the body slightly bigger and rounder than the reference picture shows. The head will look a little small compared to normal proportions, but this is a fun cartoon caricature. Follow the main body circles as a guide, drawing the withers, back and haunches. Continue the shoulder line down, drawing the top of the legs, then follow up with a big belly.

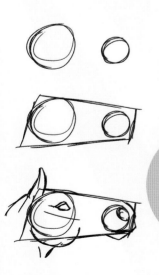

Why the long face? Horses definitely have long faces and features that can be difficult to draw in certain poses! One tip is to start the drawing with simple shapes. Some people prefer circles; others prefer rectangles. Break down the form into simple shapes and you will find that it's much easier to draw!

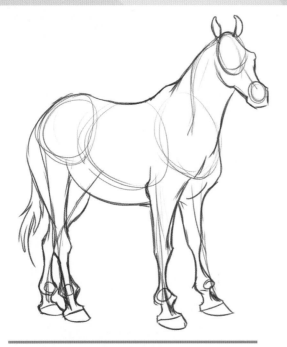

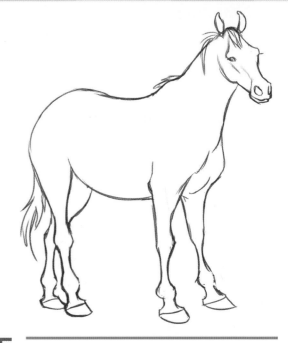

4 FINISH THE LINE WORK

Horse legs follow a wide to narrow pattern. Starting from the top, if one part of the leg is wide, the next part will probably be more narrow. Emphasize this in the caricature by exaggerating the wide and narrow parts. Horse legs start wide at the base, where they connect to the body, then narrow slightly before widening at the knees. They narrow along the equivalent of the shin bone (known as the cannon bone), then widen at the fetlock (the circular area above the hooves). After the fetlocks, the leg narrows before finally widening for the hooves.

5 ERASE THE GUIDELINES

At this stage, you can erase the guidelines. Further detail the face by adding the other eye, mane, lines for the top of the cheeks, nostrils and mouth. Finally, finish the base sketch by adding the tail; making it small emphasizes the big belly.

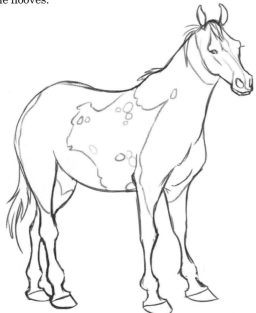

6 DRAW THE PAINT MARKINGS

Follow the reference photo carefully to see where the markings are on the horse. There is a star (a starlike mark between the eyes) and stripe (the name for a thin white marking running down the length of the face), followed by a snip (a white marking on the mouth). There is a large white patch on the belly, and the legs are mostly white.

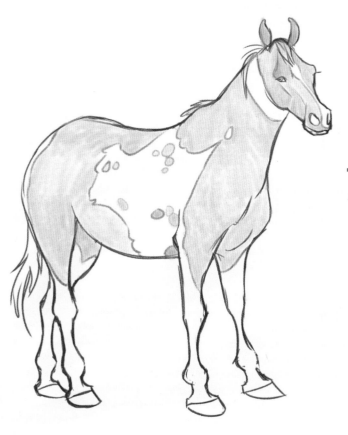

7 START ADDING COLOR

Choose a light purple and shade the areas that are dark: most of the head, ears, neck, shoulders, back and haunches, as well as the spots on the belly. Some spots are darker, while other spots are lighter.

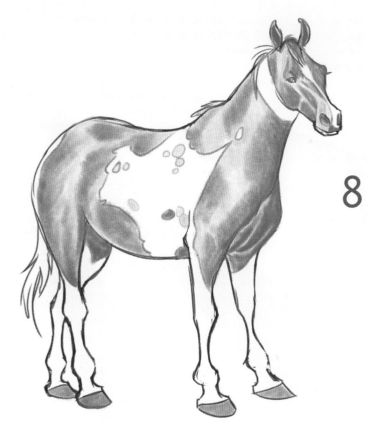

8 ADD SHADING

Select a medium purple and shade the areas in shadow. The light is coming from the left, so the areas on the right will be in shade. Add the medium purple to the right side of the face, the ears, nostrils, cheek, top and bottom of the neck, shoulders and chest, haunches and the top of the legs.

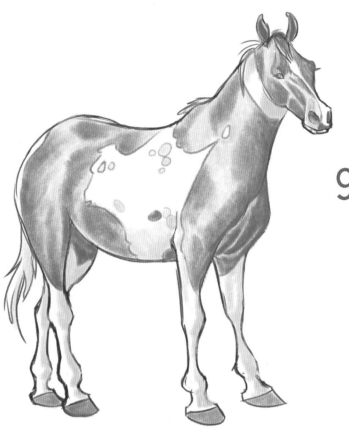

9 ADD SHADING TO THE WHITE

Take a light purple and shade the areas of white on the face, neck, belly, tail and down the legs. Choose a medium brown and shade the hooves.

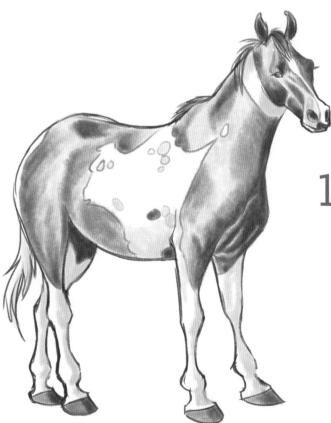

10 FINAL DETAILS

Pick a dark purple and shade the darkest areas of the ears, face, nose, neck, back and legs. Shade in the right side of the hooves. At last, your paint horse caricature is complete!

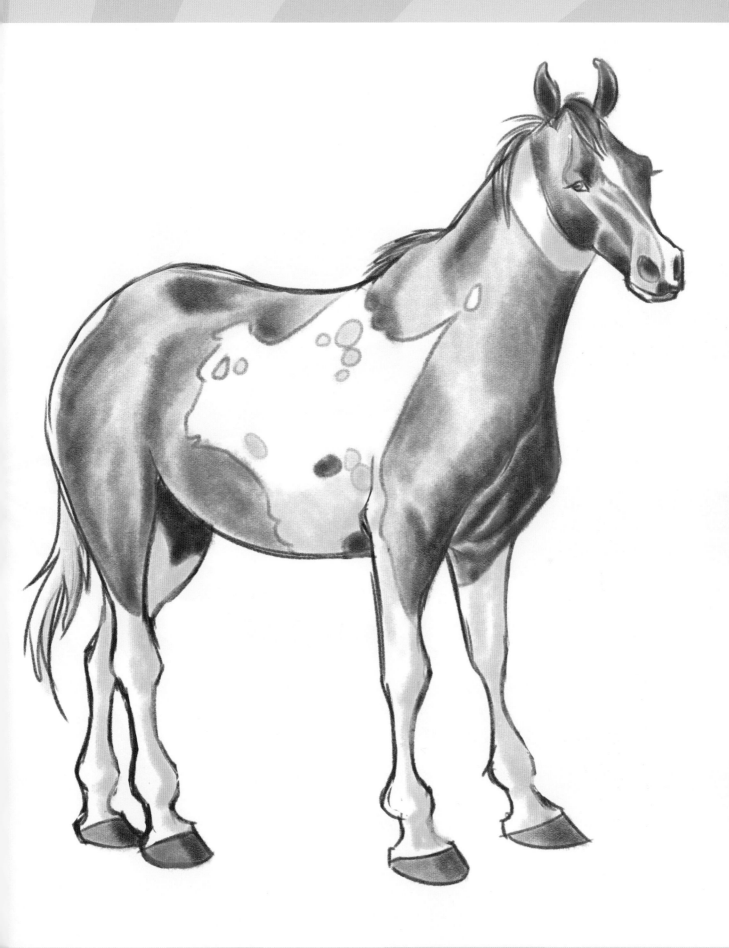

KUBLA

One of the most common colors in horses is called "bay." A bay occurs when red and brown hair grows on the face, neck and body, but black hair grows on the ear tips, nose, legs, mane and tail.

The black areas are similar in nature to a Siamese cat's point markings. If a brown horse does not have black points, it cannot be considered a bay, although white markings are allowed. There are many shades of color within bays.

This bay horse is considered a blood bay, which is a deep bloodred color. This is the most iconic-looking type of bay horse color.

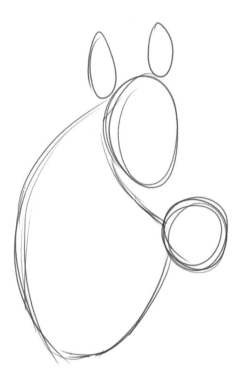

1 DRAW THE HEAD GUIDELINES

Drawing a horse that's facing you is a little different than drawing one in profile. The whole of the horse can be broken down into basic shapes in order to make it easier to draw. Start with a medium, slightly elongated circle for the base of the head. Create a smaller, more round circle below, slightly to the right. Connect the two circles with a curved line from the bigger circle to the smaller one. Draw two ovals over the bigger circle for the ears, then draw a large U shape for the neck.

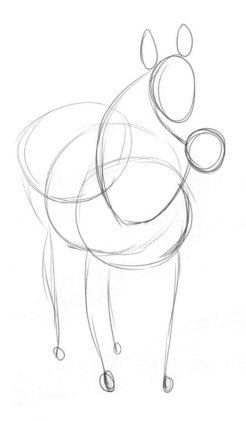

2 DRAW GUIDELINES FOR THE BODY

In order to draw the horse from the front, draw through the shapes to create a sense of overlap and depth. Drawing through the shape means to draw complete circles and shapes, not worrying if you will have to erase lines later. Draw a circle below the neck for the chest, then a larger one behind it for the belly, then one more for the haunches. Then sketch in four lines for the legs.

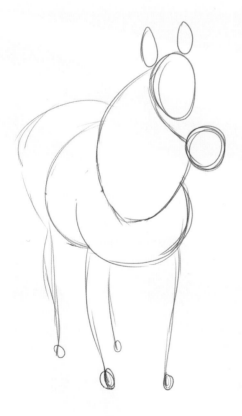

3 ERASE THE EXTRA GUIDELINES

Since you drew through the form, it's important to clean up the sketch as you go so the lines don't get too confusing. Erase the lines where they overlap in the middle of the circles, leaving the outer edges to show the chest, belly and haunches.

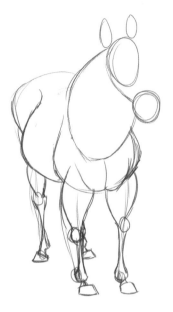

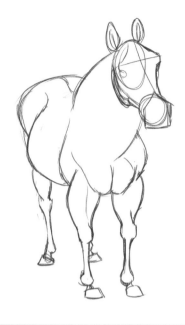

4 DRAW THE MUSCLES AND HOOVES

Now it's time to add the muscles. This horse has a very defined neck, chest and leg muscles, so it will be fun to caricaturize them! Halfway down each line you drew for the legs, sketch a circle for the knees. Next draw a curve that starts wide at the base of the body, then gets smaller as you get near the knee. Sketch more lines down toward the fetlock joint. Finally, draw the hooves.

5 REFINE THE FACE

Erase the extra lines on the legs in order to more clearly see the sketch. Draw a t shaped guideline on the head, from the forehead to the muzzle and across the top portion of the head. Sketch small circles on either side of the vertical line for the eyes. Create a wide 7 shape from the forehead to the muzzle for the side of the face. From this angle the horse's left eye will extend out a little. Next draw a box around the nose and mouth.

Horses come in a variety of colors, and every combination has a name. So it can get tricky. Sometimes even equestrians can't agree on a certain color! I don't know why, though; they all look gray to me.

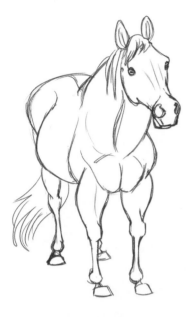

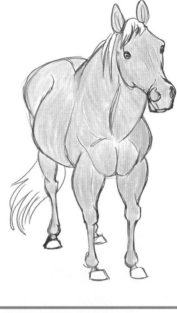

6 FINISH THE LINE WORK

Refine the outline of the head. Draw the nostrils on the top of the box created for the muzzle. Narrow the outside lines of the box slightly in order to create the horse's mouth. Draw the pupils for the eyes. Erase the guidelines in the middle of the face and muzzle. Add a swishing tail and mane.

7 START ADDING COLOR

Take a light brown color and fill in the horse's face, neck, chest, belly, haunches and legs. Even in this early stage, follow the curve of the muscles while you are shading to add dimension and form.

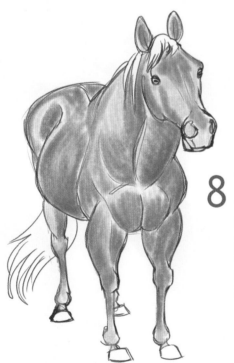

8 ADD SHADOW

Select a medium brown and add the shadow to the piece. The light source is coming from the upper left-hand side of the paper, so everything on the right will have shading, including the neck, chest, legs, belly and haunches.

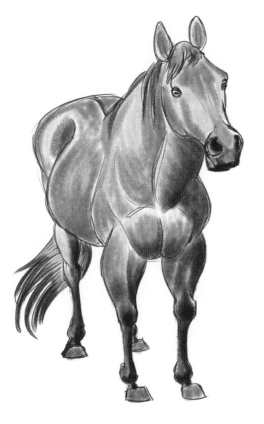

9 ADD THE DARK COLOR

Choose a dark blue and use it to shade the darkest areas, like the bottom of the muzzle, inside the ears and nostrils, under the neck, the chest, legs, tail and mane. The horse has dark markings on its legs as well, so use the dark blue to fill in the color and create darker sections for the shadows.

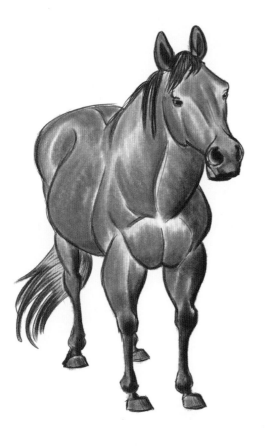

10 FINAL DETAILS

In order to brighten up the horse, select a deep medium orange color and use it to go over the brown areas of the horse. The face, cheeks, side of the neck, shoulders, belly and haunches will be the brightest. Leave some of the white showing through to mimic the shine of the horse's coat. You have finished this bay horse's cartoon!

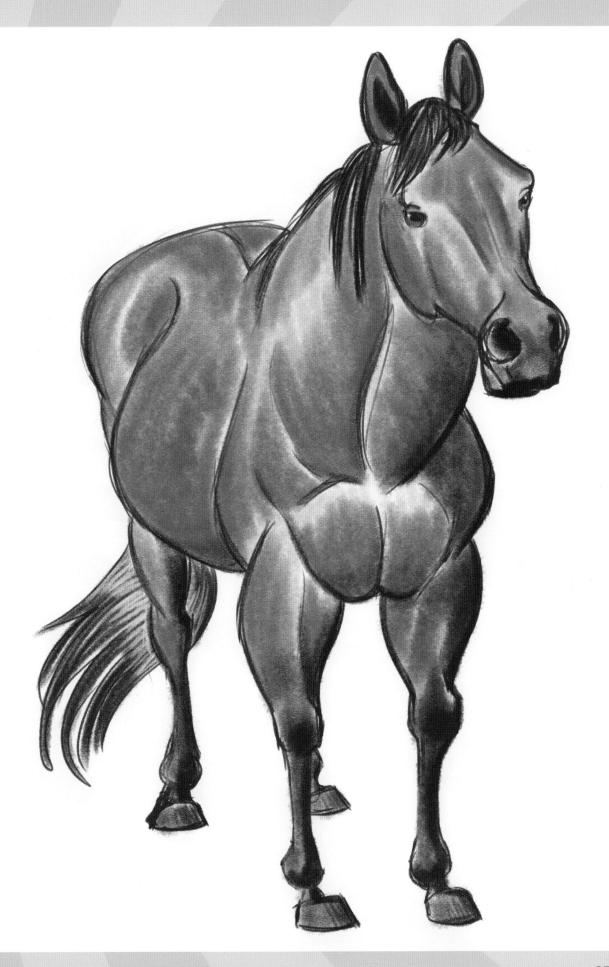

PONCHO

The equine family has many members, and among them is the donkey. Donkeys generally are smaller than horses and tend to have stubborn dispositions. They are faithful and loyal friends once they bond with their owner, though!

Another name for them is "burro," which is a Spanish word for donkey. The words can be used interchangeably. Donkeys live in the wild in Africa and have been feral in North and South America since the Spaniards brought them over in the 1500s.

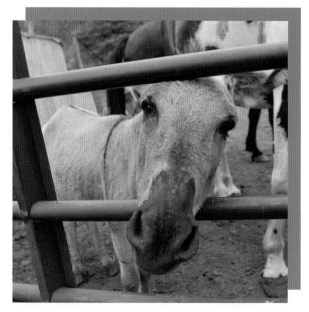

Poncho is a typical gray donkey, though they can be many other colors. Donkeys often have a dark stripe down their back and across their shoulder, forming a "T" pattern, also known as a cross.

1 DRAW THE HEAD GUIDELINES

One of the main features of donkeys is their big ears. Sometimes it's fun to enhance a feature that is less common to emphasize. In this case, let's use the reference photo of Poncho looking through the bars and show off his big nose. Start with a circle for the main base of the head and eyes. Then draw two large ovals above that circle for the ears. Next draw another larger circle below the first for Poncho's nose and mouth. This will add to the illusion of depth in the caricature. Finally, connect the circles by drawing in the outline of the face, including the eyes, cheeks and nostrils.

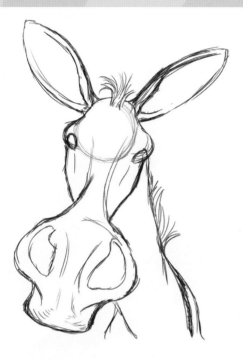

2 ADD THE EYES AND MANE

When you look at a donkey head-on, the eyes will be on the outer edges of the face. Draw two almond shapes on either side of the face. You can also add the nostrils, which are shaped like a kidney bean. Add a little sprig of mane on the forehead and down the back of the neck, along with the shoulder and shoulder stripe.

3 ERASE THE GUIDELINES

At this point you can erase the circles and guidelines and draw in the pupils of the eyes. Donkeys, like horses, have the horizontal pupil, which allows them to have almost 360° vision.

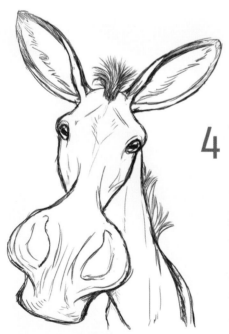

4 FINISH THE LINE WORK

Continue adding in details on the forehead, cheeks, nose and mouth. You'll find a lot of subtle wrinkles on the muzzle, which can be indicated by drawing little lines following the form of the nose and the mouth. Equine mouths are typically shaped like a rounded-off square. You can show the roundness by drawing curved lines below the nose.

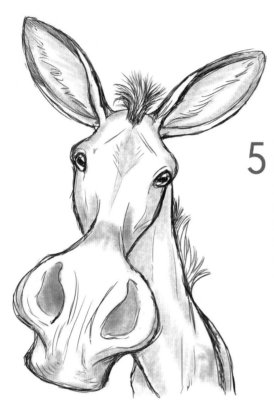

5 START ADDING COLOR

Notice the markings and where they appear around the body. Shade in the darkest points with a medium blue-gray: on the forehead, the tips of the ears, between the eyes and the nose, inside the nostrils, below the nose and on the neck.

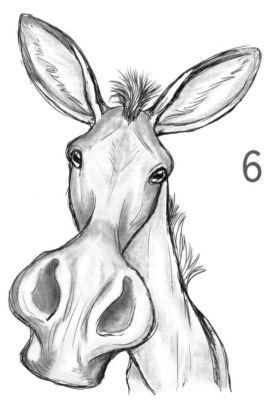

6 CONTINUE ADDING COLOR

Fill in the rest of the face with a light blue-gray. Some areas have very light tint due to muscle, skin or bone rising up on the form, such as the area above the eyes, around the edge of the nose and down the middle of the neck.

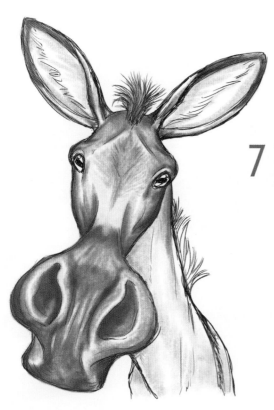

7 SHADE THE EARS AND NOSE

Use a medium gray to start shading in the darker areas of the ears, center of the forehead and nose. Also darken the area inside the nostrils and the sides of the mouth.

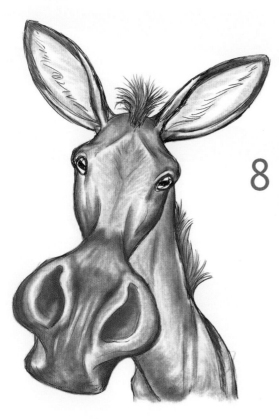

8 SHADE THE NECK

Continue using a darker gray to add the shading on the top and bottom of the neck, beneath the nose and at the edges of the nose and cheeks. An equine's neck is thinnest at the top (called the "crest") and at the bottom, with the muscles being the biggest in between. You can help render this look by shading the crest and bottom of the neck more, and leaving the area in the middle lighter.

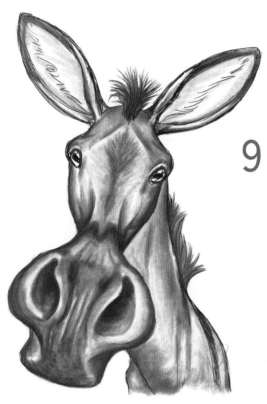

9 ADD BROWN TO THE FUR AND MANE

Poncho also has some brown fur mixed into his coat. Use a reddish brown to lightly add some color to his mane, forehead and nose in order to better reflect his true multicolored coat pattern.

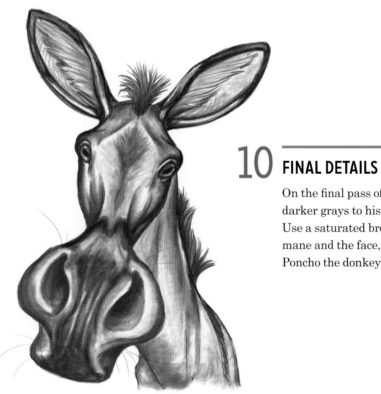

10 FINAL DETAILS

On the final pass of Poncho's caricature, add darker grays to his ear tips, cheeks and nose. Use a saturated brown to blend the colors in the mane and the face, completing this caricature of Poncho the donkey.

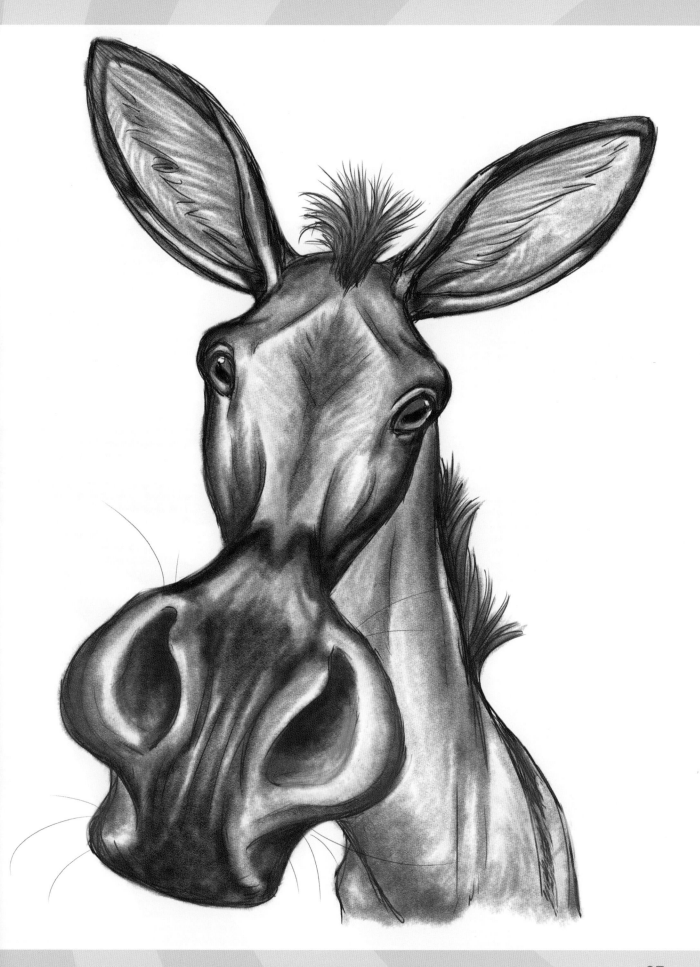

EXOTIC ANIMALS

Exotics are pets that tend to be outside the more common cat, dog and horse varieties. Exotics can include hamsters, mice, rats, parrots, chickens, lizards, snakes, frogs, salamanders and fresh and saltwater fish.

Exotic pets are a broad category of animals. They often require special care in order to keep them healthy and happy. Because these pets are less common, it is generally harder to find the proper food for them, and their owners have to take them to specialty vets when they get sick. Owning an exotic animal is a big responsibility, and you must be well educated about their care before purchasing one.

Mammals

Many different types of mammals fall under the exotic category. Some are gaining popularity, like ferrets and hedgehogs, while some, like the sugar glider and degu, are more obscure. When drawing them, play with the form and personality. If a ferret is long and skinny, you can cartoon this by drawing a superlong and wiggly ferret!

Birds

With colorful wings and feathers, birds are beautiful. The most common variety of pet bird is the budgerigar, or parakeet, as it's better known. Parrots are popular pets due to their intelligence and word-mimicking abilities. Finches are largely owned by bird enthusiasts who love to observe wild, natural bird behavior. Increasingly common is the practice of owning chickens. Many owners love the fresh eggs hens provide, and there are many varieties that can be very friendly.

Fish

Fish are popular pets. Many people's first experience with these animals is owning a Siamese fighting fish, or betta fish. The males come in a variety of colors with long, flowing fins. They are solitary animals that do not like to be housed with their own kind. Other fish that get along better are freshwater tropical varieties, such as fancy guppies and platies. All fish have special tank requirements, but saltwater fish require even more setup and attention. Fish are extremely beautiful and colorful, which can make for some excellent cartoons!

Reptiles and Amphibians

Reptiles and amphibians are interesting pets. They are very different from people (snakes have no legs) and perhaps that's why we find them so interesting. Owners tend to gravitate to the placid nature of reptiles in captivity, such as ball pythons, some iguanas and bearded dragons.

BRAMBLEBURR

Many small mammals tend to have a round body and short legs. Almost no animal exemplifies these traits as well as a hedgehog. They can literally roll up into a ball. You can't get any rounder than that!

Brambleburr is my pygmy African hedgehog. He is an albino, which means he lacks all color pigment in his body, making him white with red eyes.

Hedgehogs are nocturnal animals that are most active at night. They love to sleep, eat and run in their wheel.

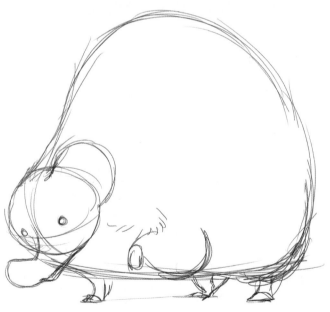

1 DRAW THE BASIC GUIDELINES

In order to help caricaturize Brambleburr, draw a big somewhat vertical oval to indicate the main part of his body. Draw a smaller circle for the head and a tubular shape to show where the nose will be. Two small circles can be drawn midway inside the bigger circle to show the beady hedgehog eyes. Below the oval, draw each of the four legs, which are triangular at the base and end in small horizontal ovals for the feet. One paw up in the air lends personality and expression to the caricature even at this early stage.

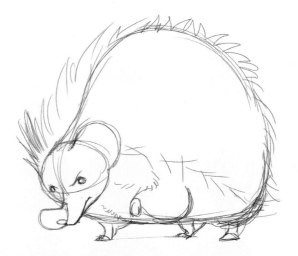

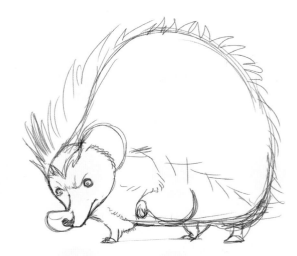

2 DRAW THE QUILLS

Add the iconic quills that make up the hedgehog's forehead, back and sides. Quills are cone shaped, so keep this in mind when layering them on the form. When not alarmed or threatened, the hedgehog quills lay flat on top of one another. Hedgehogs tend to be grumpy creatures, so giving Brambleburr an annoyed expression isn't out of place. Fill in the details of the nose, following the reference photo.

3 DRAW THE HEDGEHOG'S EXPRESSION

Enhance the expression by detailing the eyes and adding pupils. Indicating an eyebrow over the eyes will add to the expression and make Brambleburr look more perplexed. Hedgehogs have two canines spaced slightly apart from one another, which give them a vampire look. Adding a little pointy tooth or two will emphasize the expression because animals tend to show teeth when they are aggravated.

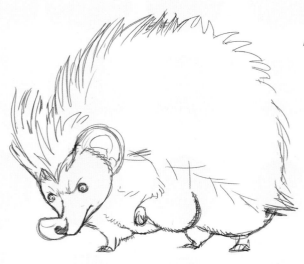

4 ADD MORE DETAILS

Hedgehogs have an interesting aspect to their anatomy; they have two separate muscles on each side of their body to control their quill movement. You can see this best on the facial quills. Draw another series of quills between the outer quills and the ear. Hedgehogs have flat ears, similar to ferrets. Draw in the details of the ear; hedgehogs tend to have circular patterns on the inside of the ear.

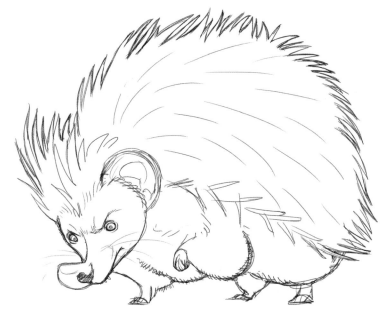

5 FINISH THE LINE WORK

Add more detail to the quills, outlining them more clearly over the roughly sketched-in quills. Indicate more quills across the body by sketching in lines, moving from the head to the back. In order to draw the quills on the side, draw a horizontal X pattern, then draw a triangular cone shape on the edges of the X shape. This will make it look like the quills are crossing over each other, which they frequently do.

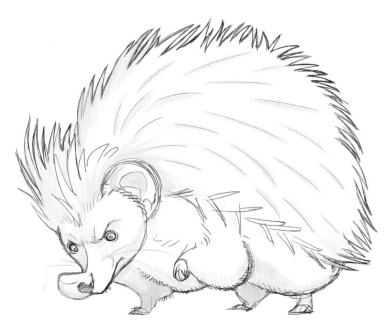

6 START ADDING SHADING

It's time to add shading! Pick a direction that the light source is coming from and shade the areas that would not have light shining on them. For instance, if the light sources comes from the upper right-hand side of the page, the lower left-hand side of the hedgehog will be in shadow. The best color to use for shadowing white animals is a blue or a purple; either will bring more vibrancy and life to your caricature.

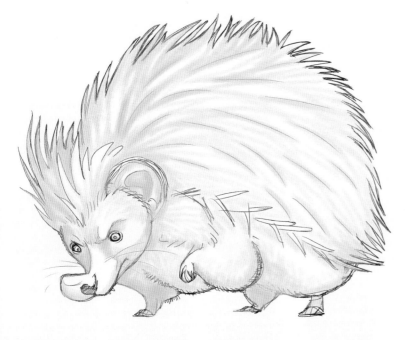

7 ADD MORE SHADING

Now that the main areas of shadow are determined, you can move on to shading the more intricate details. Keep your strokes light; it's always easier to add shading than it is to take it away. Color the strokes in the direction of the fur, from the head swooping over and down toward the back of the body. Color in inverted V shapes to show the quills across the back and sides.

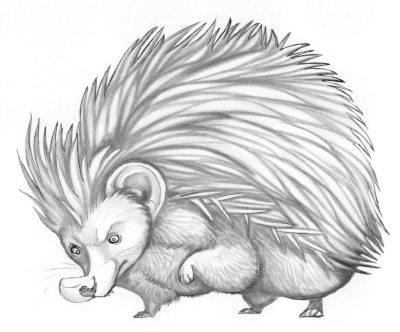

8 ADD THE DEEPEST SHADOWS

Take a darker color of blue or purple and go over the edges where the deepest shadows occur. You can further detail the quills by shading at the base of each quill. The underside of a hedgehog is covered by coarser fur. It's not very soft, but it is softer than the quills on the top! Shade in the fur details on the legs and stomach.

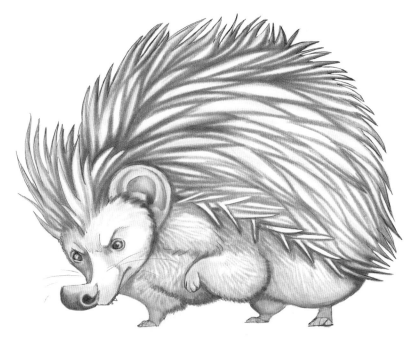

9 ADD PINK

Besides being white, the primary distinction of albino animals is their pink skin and red eyes! Add a light pink color to the ears, toes, underbelly and nose as well as the eyes. Add a darker red to the pupils of the eyes. A true albino animal has no pigment in its skin (pigment adds color to an animal), so even the pupils are clear, getting their red color from the blood behind the eyes.

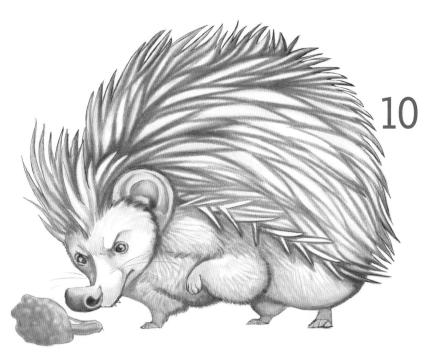

10 FINAL DETAILS

Sometimes to make the caricature more humorous, you can add props or an environment to help tell a story. Hedgehogs are insectivores by nature, mostly eating bugs, only occasionally eating plants and meat. More than likely, a hedgehog is going to turn up its nose at a piece of broccoli, so it's a fun addition to the caricature that will clearly show why Brambleburr is so grumpy!

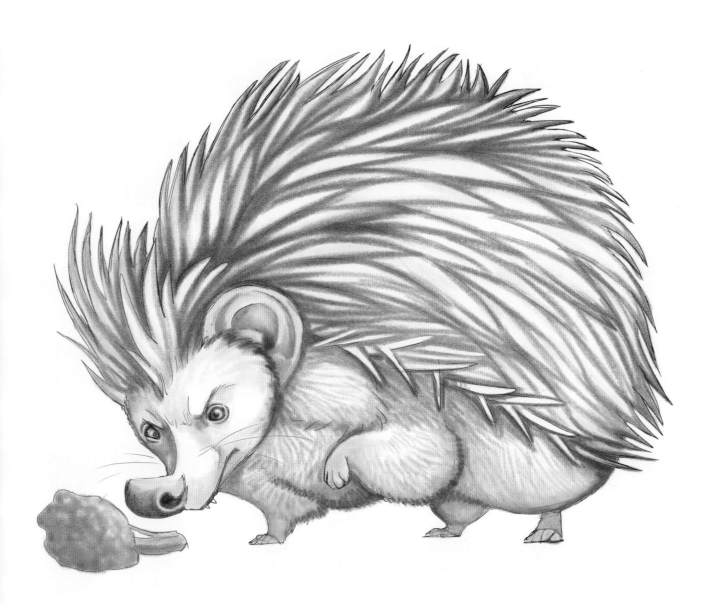

ISABELLA

There are many species of birds, and they are different sizes, shapes and patterns. Some birds have long, elegant necks, like swans, and some have necks that seem to merge right into their bodies. Many birds are kept as pets, and an increasingly more popular option is the chicken!

Isabella is a Mille Fleur d'Uccle bantam hen. Pretty fancy, right? There are many different species of chickens, and they are fascinating to learn about. Some chickens have feathers that are more like the fluffy hair you'd find on a cat than the plumage of a bird. Learning about these differences will help your understanding of bird anatomy and create a more believable piece of artwork.

Isabella (in the foreground) is a gorgeous example of a Mille Fleur d'Uccle bantam chicken hen.

1 DRAW THE BASIC GUIDELINES

Isabella's body is large and round. Starting off with a bigger-than-real-life body will help emphasize this in the caricature. Next draw a small circle above the body for the head and add the beak. The shape of the beak is a unique feature to chickens. It is blunt on the end since they peck at the ground. You can tell what kind of food a bird eats based on the bird's beak. Draw rough triangles on the back part of the body to indicate the tail and the bottom of the wing. On the bottom of the body, draw two triangular shapes for the legs. The feet will be smaller than reality to help the size of the body stand out.

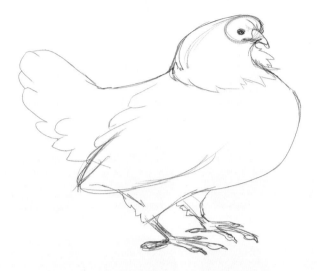

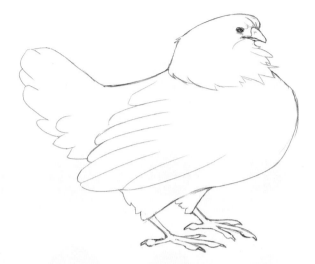

2 REFINE THE SKETCH

Add more details at this stage to help fill out the shape and attributes of Isabella's body and face. Chickens have relatively small eyes compared to many other birds, so you can enhance this feature of the caricature by drawing the eye really small. Fill in the details of the beak shape, paying close attention to the reference photo. You can indicate more of the wing by extending the lines into the main part of the body. Start detailing the individual tail feathers as well.

3 ERASE THE GUIDELINES

You can erase some of the guidelines you used for drawing the caricature so far. Add more detail to the wing by drawing the primary feathers that extend past the body. I emphasized Isabella's expression to look a bit disapproving by drawing the base of her beak pointing downward slightly and giving her a heavy eyelid. Adding expressions helps give personality to any kind of animal, even chickens!

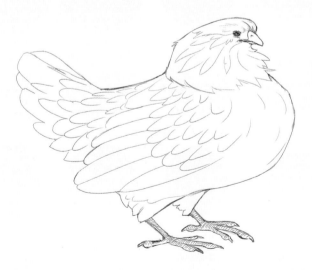

4 DRAW THE FEATHER DETAILS

At this stage, it's important to draw the details of the feathers around the whole body in order to help keep track of the feather pattern. Feathers grow in a certain way on birds, radiating out from the head and downward toward the body. They typically end in larger feathers on the tail and wings.

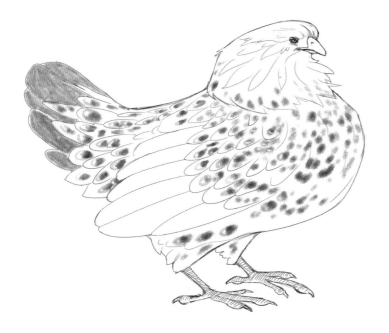

5 DRAW THE PATTERN

Mille Fleur d'Uccle bantam chickens have a unique pattern to their feathers that makes them easy for chicken connoisseurs to identify. Now is a great time to draw in these unique spots. The spots are black and white, and they cover the chicken's entire body, starting at the base of its neck and making their way down to the black-tipped tail.

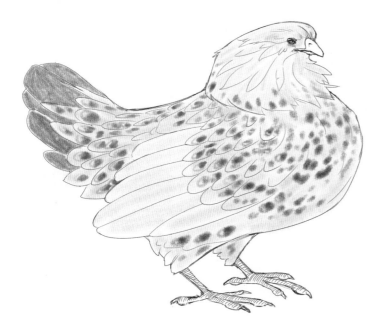

6 ADD THE FIRST LAYER OF COLOR

Another distinguishing characteristic of the Mille Fleur d'Uccle bantam hens is their brilliant bright orange coloration. Start to lay in a yellow color lightly over the sketch. Keep it light at this stage and gradually add color in order to produce a deeper hue.

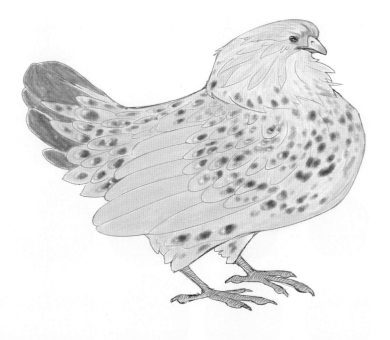

7 CONTINUE ADDING COLOR

Continue coloring in the light yellow color, filling out Isabella's form. You can use a light blue-gray to shade in the darker points of the hen, including the tail, feet and beak. Finally, use a light red or pink color to fill in the area between the eyes and beak. Chickens commonly have a "comb" or a red flap of skin on top of their heads, over their beaks. Isabella doesn't have a comb, proving that you must always check your reference photo because every animal is different!

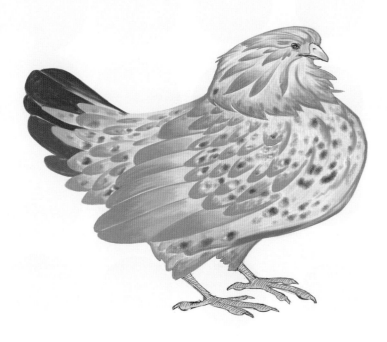

8 ADD DARKER COLORS FOR SHADING

Use a darker golden color to outline the edges of the individual feathers, providing contrast and allowing the feathers to better fill out Isabella's form. Also use the dark blue-gray to color in the tail feathers.

9 DEFINE THE FEATHERS

Start from the head and work your way
down the body, adding light orange and
dark orange to the edges of the feathers.
Make sure the edges are darker to make
it look like the feather is overlapping the
lighter yellow base of the feather below
it. Making the feathers graduate from
yellow to dark orange gives them a more
three-dimensional look.

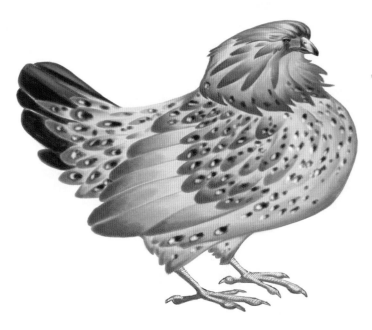

10 FINAL DETAILS

Create the overlapping feather pattern
over the whole body, wings and tail.
Reintroduce the spots if they were covered
up by the yellow and orange colors.
You can add a light red or rose color to
Isabella's face to fill out the area between
the eyes and the beak. Add a dark blue-
gray color to the tail to help bring out the
feathers. Use that same blue-gray color to
shade Isabella's feet.

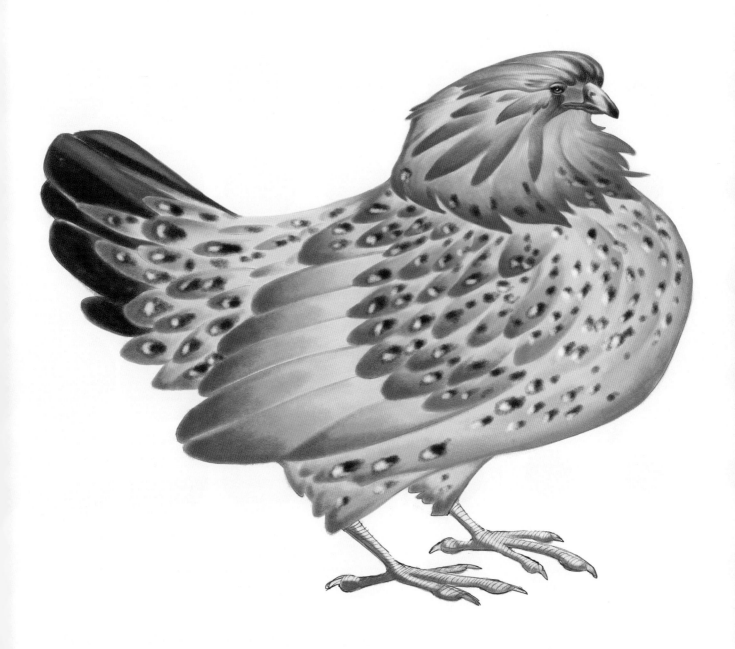

SHAZBOT

Reptiles are a diverse group of animals that take many different forms and sizes. They are classified as reptiles because they are cold-blooded, they lay eggs and they have scales.

Reptiles generally reside low to the ground and have short legs and long tails. In the case of snakes, legs are optional!

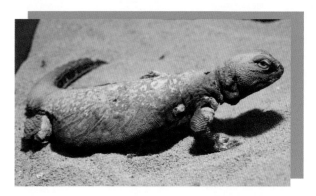

Shazbot is a pet uromastyx, a species of lizard from Africa and Asia. Shazbot has wonderfully bright coloration and markings!

1 DRAW THE BASIC GUIDELINES

The uromastyx is low set and stays on the ground, and its body reflects this adaptation. Start by drawing a circle for the head, then a larger oval shape next to it, making sure to make the side of the oval wider at the back end of the uromastyx. Next draw cylinders and circles for the front and back legs and then the tail.

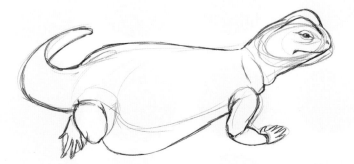

2 ADD MORE DETAILS

Go over your sketch and create the outline
for the uromastyx. In order to help caricature
this lizard, make the body a bit wider and
the "eyebrows" over the eyes larger to help
emphasize these traits. Add toes to the feet,
and draw the eyes, nose and mouth.

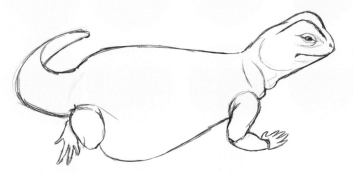

3 CLEAN UP THE LINE WORK

After the caricature takes shape the way you
want it to, erase the guidelines in order to see
the body better. You can also add some texture
around the neck to account for the folds of skin.

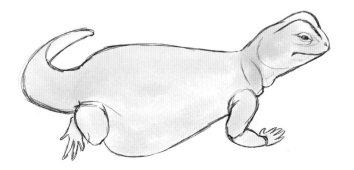

4 START ADDING COLOR

Pick a light purple-blue color and shade Shazbot's body, legs, head and tail. Choose a medium yellow to hint at the yellow markings on Shazbot's back.

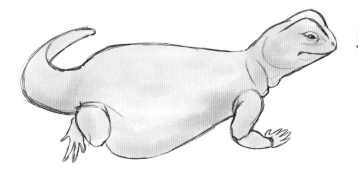

5 DARKEN THE COLOR

Grab a slightly darker purple and color in the area below the body, on the belly, on the bottom of the legs, the cheeks and the bottom of the tail. Keep a light hand because you will want to build up colors later to create more texture and depth in the caricature.

6 CONTINUE DARKENING THE COLOR

Continue adding deeper purples and some blues to the shadows of the body. Building up the colors in this way allows you to blend the colors together and create a unified look.

7 ADD WRINKLES AND SPOTS

Be sure to check the reference photo while adding color to your work. At this stage, start paying attention to the folds of skin, wrinkles, scales and other features of Shazbot's body, and apply them to your drawing. You can use a dark saturated blue to apply the ringlike spots on the lizard's back and the scales on the tail.

8 ADD DARK SHADOWS

Use a really deep dark blue to cover the sketchy outline on the bottom of the lizard. This will bring your work up to a more detailed level and make it look more polished. Add shadows to the face, cheek, neck and legs as well.

9 FINAL DETAILS

Use a dark yellow to highlight the markings on the back. Next choose a dark blue to draw hashlike markings (#) along the stomach, knees, legs, neck and cheeks. This pattern will give the impression of scales, which will complete Shazbot's caricature!

LUCY

Amphibians are a unique group of animals that are mainly characterized by having a life cycle that happens in stages, usually an egg, tadpole, then adult. They can also breathe through their skin!

Not all pets live inside your house. Some animals are pets by association or proximity. A squirrel tree frog lives in the woods behind my house and even makes its home *on* my house. It's fun to look through the windows at it eating bugs and to take pictures. It's important to keep wild animals wild though, so I look, but I don't touch.

Dubbed Lucy, this squirrel tree frog is very photogenic.

1 SKETCH THE BODY GUIDELINE

Start by drawing an oval for the main part of the body. Draw the first action line from the top of the oval to the bottom, looking at your reference photo and following the line of the spine. Next draw another action line wrapping around the center of the oval.

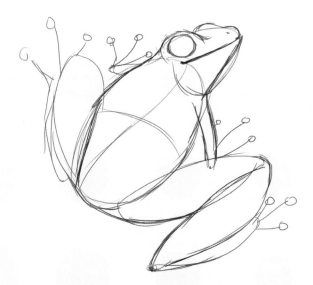

2 DRAW THE LEGS AND HEAD

Draw a triangle shape for the head at the top of the oval. To encourage the look of the caricature, draw two large semi-circles on the top of that triangle for the eye sockets. Draw the back legs using overlapping ovals. Frog legs are made up of three long cylinders. Next create thin cylinders for the front legs.

3 REFINE THE SKETCH

Draw a circle for the eye. Create a line from the top of the mouth under the eye. You can draw a little smile to emphasize the caricature. Next draw three lines followed by a circle at the end on each one of the feet. These are the start of the toes.

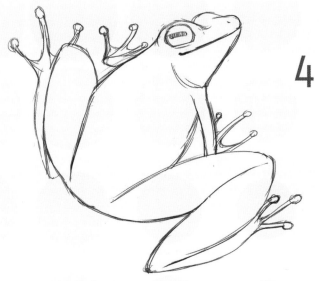

4 ERASE THE GUIDELINES

Erase the guidelines, then smooth out the borders. Draw in the toes and add the pupil. In order to increase the look of the smile, erase the bottom of the eye and draw a straight line across. Draw a little line under the eye to show the eye's form under the eyelid.

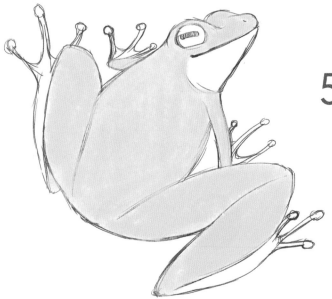

5 ADD THE FIRST LAYER OF COLOR

Select a light green and shade the head, back, front legs and back legs. Leave the chin, eye, feet and lower back legs white for now.

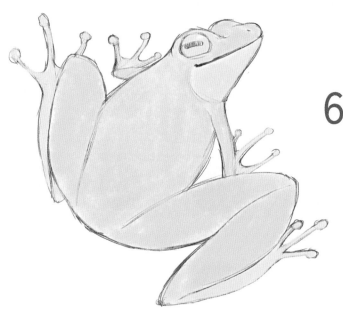

6 ADD MORE COLOR

Choose a medium yellow and color the feet and lower back legs. Shade in the eye as well, leaving a corner of the eye white. This will allow for a highlight on the eye later in the piece.

7 OUTLINE THE FROG

Pick a medium green and draw a border around the top of the head, eyes, mouth, upper arms, body and upper legs.

8 ADD SHADOWS

Use the medium green and shade the head, back and legs. Leaving some areas unshadowed along the contours of the body creates the look of highlights and wet skin. Next choose a medium orange and color the tips of the toes, the space under the chin and the leg joints.

9 FINAL DETAILS

Select a lime green and shade the side of the body and the tops of the legs. Select a medium brown and color the top of the eye, blending the sides of the pupils into the yellow base. Color around the white highlight to allow the eye to shine. Choose a medium blue and color in the pupil. Lucy's caricature is done!

Egg

Tadpole

Adult

Amphibians have a special life cycle. They start out as an itty-bitty egg, then they morph into a tadpole. Next they start growing arms and legs, and finally they lose their tails and hop away!

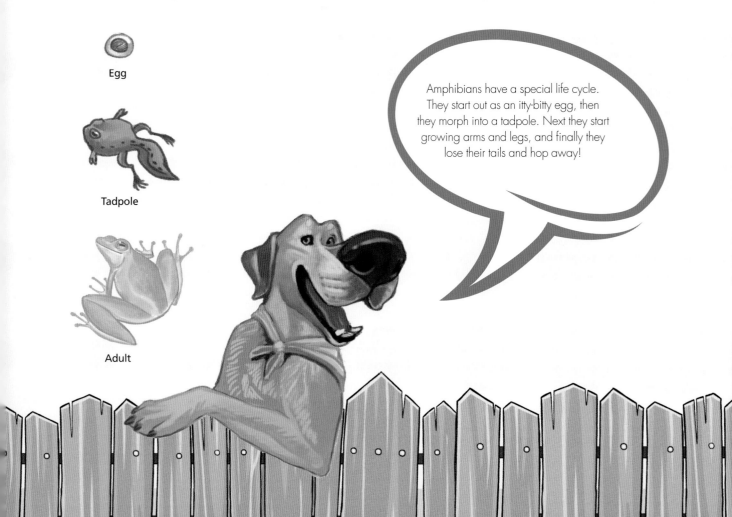

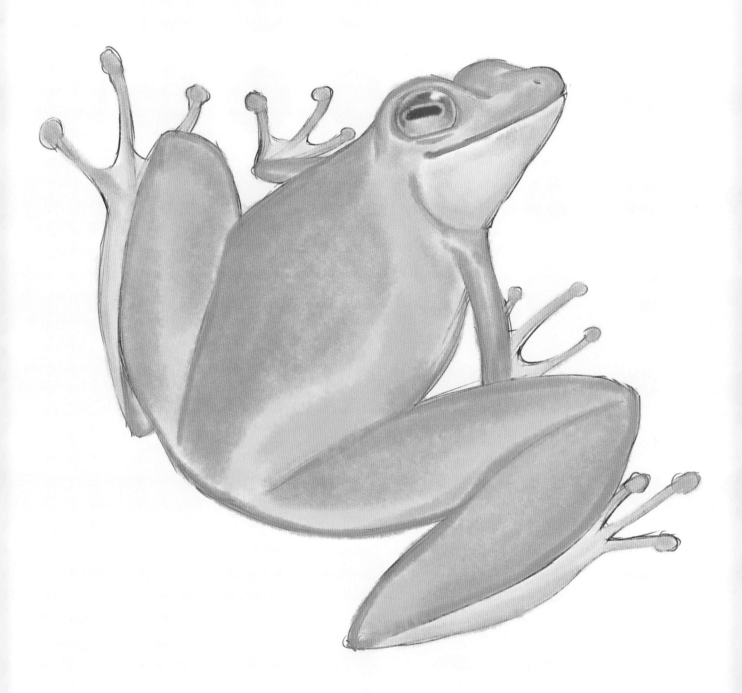

CASPIAN

There are a lot of different fish in the world, but one of the most common fish kept as a pet is the betta!

Betta fish, also known as Siamese fighting fish, are colorful fish that have relatively beginner care levels and needs. Male bettas are the most common to keep as pets, since they have long, flowing fins and bright colors. The females have smaller fins and usually muted colors. Both male and female bettas have a dorsal fin on their back, a tail fin, a pectoral fin on their side and a large stomach and ventral fins on their underside.

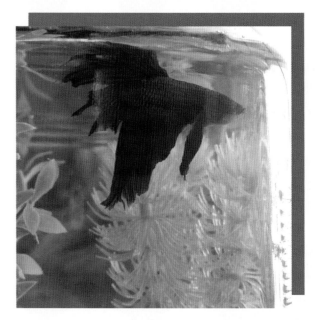

This betta is a beautiful deep red with long graceful fins.

1 SKETCH THE BODY SHAPE

Male bettas have small oval bodies with elaborate flowing fins. In order to create a fun caricature of this betta, start with a small oval shape. Next add a triangular shape to one side of the oval for the betta's head.

Dorsal fin

Caudal fin

Ventral fin

Anal fin

2 DRAW THE FINS

Male bettas have large fins covering much of the body. Female bettas have shorter, rounder fins. Draw the shape of the dorsal fin by creating large swooping lines. There is also the tail fin, which is smaller on this betta. Use lots of flourishes and squiggly shapes for the outline of the tail fin. To create the large fin on the bottom side of the betta, draw a long line leading down to the bottom of the page exaggerating the fin's shape. Finish the fins by adding the long thin ventral fin on the bottom of the betta, near the head.

3 DRAW THE FACIAL FEATURES

Bettas mouths are almost on the top of their bodies. That is because in the wild, they eat bugs and plants from the surface of the water. Draw a line coming down from the top of the head for the mouth. Sketch a large circle for the eye. Bettas also have fins on the sides of their bodies called "pectoral fins." These help them maneuver in the water. Draw this fin next to the eye using a triangular shape and add in the veins of the fin as well.

4 DRAW THE FIN VEINS

In order to give the fins volume and shape, draw veins from top to bottom. Be sure to draw flowing lines that accentuate the flowing form of the fins. Start the lines at the base of the body and have them radiate toward the outer edges of the fins.

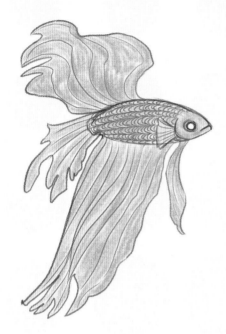

5 ADD SCALES

Create the scales along the body. Bettas have horizontal rows of scales along their bodies. Start by drawing horizontal lines; this will help keep your scales in line. Then draw C shapes, starting from the head and ending at the base of the tail.

6 ADD THE FIRST LAYER OF COLOR

Select a medium rose or red color and lightly shade the head, body and fins of the betta. You can leave some areas of white between the lines of the fins to show contrast and visual interest.

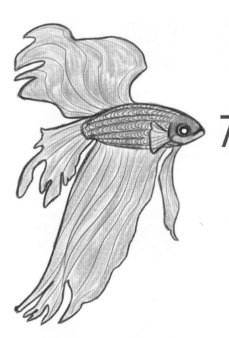

7 OUTLINE THE EDGES

Select a dark red to outline the edges of the head, eyes, back, top fin, tail, bottom fins and pectoral fin. Lightly outline the horizontal lines running along the length of the betta as well.

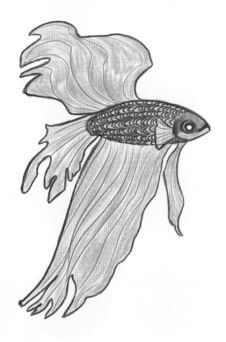

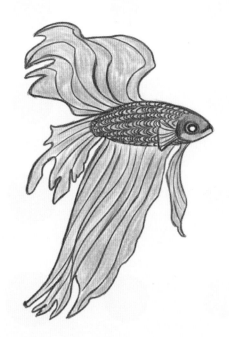

8 OUTLINE THE SCALES

Use the dark red to outline the scales along the body. Draw over the scales using the same C shape you used when creating the fish's skin texture.

9 OUTLINE THE VEINS

With the same dark red, outline the veins in the betta fish's fins. This will create a base that will show through when you apply more color in the next step.

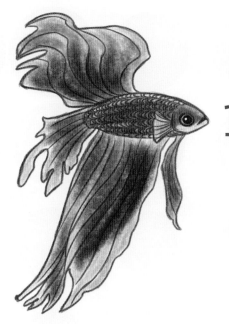

10 FINAL DETAILS

Choose a medium purple color to lightly shade the center of the betta's body, top fin, tail and bottom fins. Pick a dark red to go over the purple color in order to create a sense of depth in the fish's coloration. Finally, use a dark purple to fill in the betta's eye and complete the cartoon!

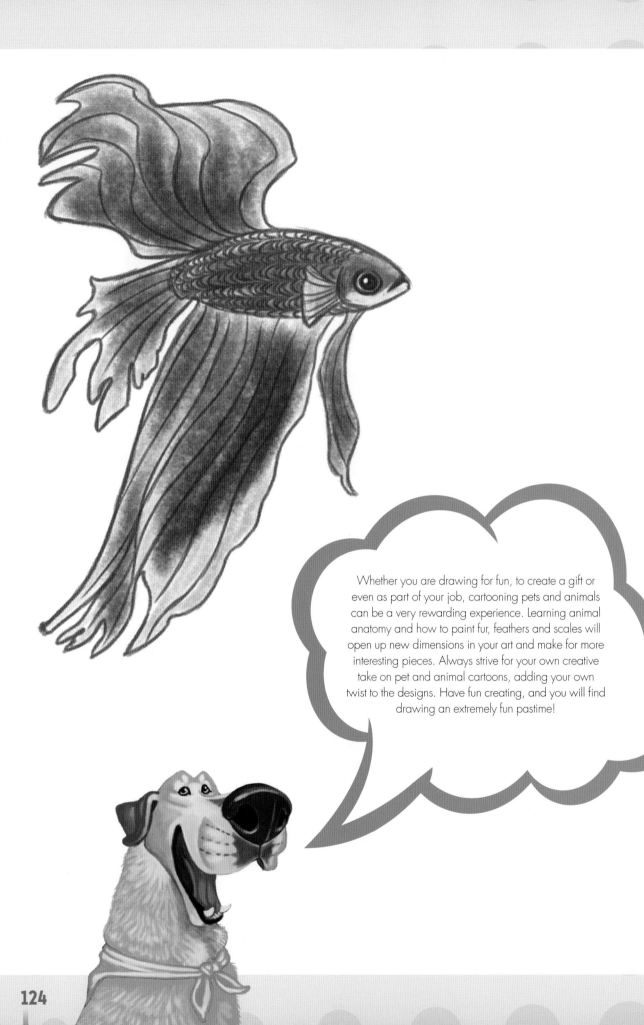

Whether you are drawing for fun, to create a gift or even as part of your job, cartooning pets and animals can be a very rewarding experience. Learning animal anatomy and how to paint fur, feathers and scales will open up new dimensions in your art and make for more interesting pieces. Always strive for your own creative take on pet and animal cartoons, adding your own twist to the designs. Have fun creating, and you will find drawing an extremely fun pastime!

INDEX

ABOUT THE AUTHOR

Char Reed has drawn and painted since she could hold a crayon, so during high school she decided to mold the hobby she did most of the time into her career. She originally wanted to do only wildlife art, but her love for pets prompted her to blend her passions into pet portrait and caricature art. She maintains a sense of whimsy while applying the realistic touch of a wildlife artist in her one-of-a-kind pet caricatures and portraits.

Currently residing in the United States, she has lived in Norway, and traveled to France, the United Kingdom and Australia. In Australia, she met one of her favorite animals, a cheetah named Nova. She horseback rides frequently and has worked at pet stores, caring for a multitude of animals from cockatoos to tarantulas. She has even owned an albino hedgehog named Brambleburr. You can find more of her art at CharReed.com.

a content + ecommerce company

Other fine IMPACT Books are available from your favorite bookstore, art supply store or online supplier. Visit our website at fwcommunity.com.

19 18 17 16 15 5 4 3 2 1

DISTRIBUTED IN CANADA BY FRASER DIRECT
100 Armstrong Avenue
Georgetown, ON, Canada L7G 5S4
Tel: (905) 877-4411

DISTRIBUTED IN THE U.K. AND EUROPE
BY F&W MEDIA INTERNATIONAL LTD
Brunel House, Forde Close, Newton Abbot, TQ12 4PU, UK
Tel: (+44) 1626 323200, Fax: (+44) 1626 323319
Email: enquiries@fwmedia.com

DISTRIBUTED IN AUSTRALIA BY CAPRICORN LINK
P.O. Box 704, S. Windsor NSW, 2756 Australia
Tel: (02) 4560-1600; Fax: (02) 4577 5288
Email: books@capricornlink.com.au

ISBN 13: 978-1-4403-4219-6

Edited by **Beth Erikson**
Designed by **Elyse Schwanke**
Production coordinated by **Jennifer Bass**

METRIC CONVERSION CHART

To convert	to	multiply by
Inches	Centimeters	2.54
Centimeters	Inches	0.4
Feet	Centimeters	30.5
Centimeters	Feet	0.03
Yards	Meters	0.9
Meters	Yards	1.1

SEE MORE OF DENVER AT
GUILTYDOGADVENTURES.COM

ACKNOWLEDGMENTS

I thank Mona Clough for believing in this book and Beth Erikson for all of her help in putting it together. I thank Mali and Denver for the opportunity to do my first ever book, which led me to do more, including this one! I would like to thank my teachers in school who let me draw in their classes, thereby allowing me to gain at least twelve years of artistic experience. I'd like to thank my friends, all of them, for being there through the tough times of my art career and for always supporting me. And finally, I want to thank my family, who has supported my art career from the first drawing and always said they would only be disappointed if I didn't grow up to be an artist.

DEDICATION

A special dedication to my inspiration, my little hedge-hog buddy, Brambleburr, who didn't make it to the end of this book project with me, but lived a long hedgehog life. I miss you, you little grumpy lumpkin!

I've had a lot of pets in my life and a lot of them were in my life for a long time. I'm sad to say my dog from high school is no longer with us anymore, but I'm glad to have had her in my life as long as I did. Sierry, you were one crazy, neurotic, smart, silly, treat-loving pup. I can't believe you are gone. I love you and I really, really miss you.

IDEAS. INSTRUCTION. INSPIRATION.

Download FREE bonus content at impact-books.com/cartoon-animal-friends.

Check out these **IMPACT** titles at impact-books.com!

These and other fine **IMPACT** products are available at your local art & craft retailer, bookstore or online supplier. Visit our website at impact-books.com.

Follow **IMPACT** for the latest news, free wallpapers, free demos and chances to win FREE BOOKS!

Follow us!

IMPACT-BOOKS.COM

- ▸ Connect with your favorite artists
- ▸ Get the latest in comic, fantasy and sci-fi art instruction, tips and techniques
- ▸ Be the first to get special deals on the products you need to improve your art